Cindy Lammon

Flowers All Around

Garden-Inspired Quilts

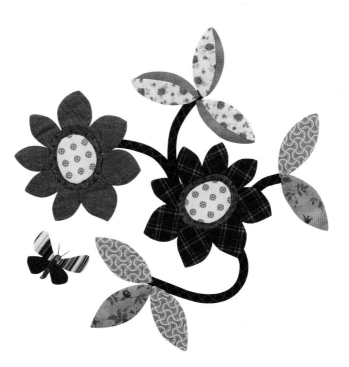

Martingale®
& COMPANY

Dedication

In memory of my parents, Ann and Steve Pociluk, who taught me the deep satisfaction that comes from giving "all of myself" to everything that I do.

Acknowledgments

I'm fortunate to be surrounded by wonderful people who inspire and support me. Thank you to:

The staff at Martingale & Company for their dedication to publishing wonderful books that keep us all inspired.

All the quilters I've taught, shopped with, sewed with, and attended guild meetings and retreats with, whose names are too numerous to mention here. Your encouragement and generosity (thanks for the fabric, Bonnie!) are truly appreciated.

Lyna Dagley, owner of Raspberry Patch Quilt Shop, for keeping me in fabric and allowing me a venue to showcase my work.

My husband, Mike, whose love and support keep me sewing and creating.

Flowers All Around: Garden-Inspired Quilts
© 2010 by Cindy Lammon

That Patchwork Place® is an imprint of Martingale & Company®.

Martingale & Company
20205 144th Ave. NE
Woodinville, WA 98072-8478 USA
www.martingale-pub.com

Printed in China
15 14 13 12 11 10 8 7 6 5 4 3 2 1

Library of Congress Cataloging-in-Publication Data is available upon request.

ISBN: 978-1-56477-977-9

Mission Statement

Dedicated to providing quality products and service to inspire creativity.

Credits

President & CEO: Tom Wierzbicki
Editor in Chief: Mary V. Green
Managing Editor: Tina Cook
Developmental Editor: Karen Costello Soltys
Technical Editor: Nancy Mahoney
Copy Editor: Marcy Heffernan
Design Director: Stan Green
Production Manager: Regina Girard
Illustrator: Adrienne Smitke
Cover & Text Designer: Regina Girard
Photographer: Brent Kane

Contents

The Quilts

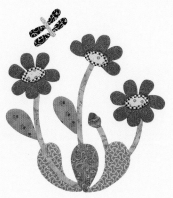

Introduction

My love of flowers and plants led to a collection of historical botanical prints. I've collected books, calendars, dishes, and prints with reproductions of seventeenth- and eighteenth-century botanical art. The appeal for me is in the simplicity of the stylized plant images and the marriage of beauty and scientific accuracy in the art. Before the invention of the camera, botanists and artists worked together to create the wonderful prints we enjoy today as art.

I continue to be inspired by botanical art and my own garden. Creating simple appliqué and pieced designs of flowers and plants has become one of my favorite pastimes. Stylized flowers, interpreted in appliqué, are found in several of the quilts in this book. Floral fabrics and traditional garden quilt blocks round out the projects. I've even included some of my favorite gardening tips! My hope is that you'll have as much fun as I've had making these projects and that your home, too, will be filled with your own botanical quilt art!

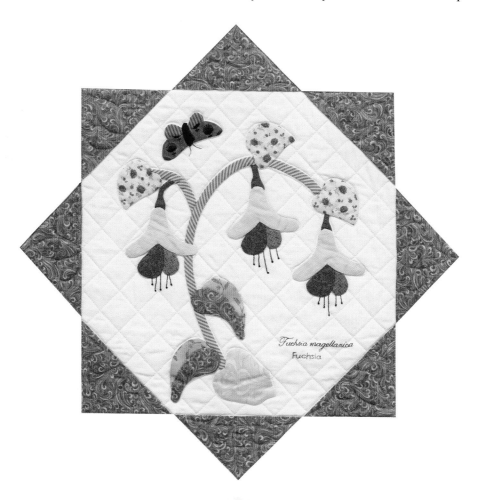

Quiltmaking Basics

There are as many techniques in quiltmaking as there are quilters. On the following pages, you'll find the basics of piecing and appliqué that work for me. Feel free to use your own methods or follow my tips and try something new.

Selecting Fabric

Choosing the fabric for a quilt is probably my favorite part, and my fabric stash can attest to that! The easiest thing to do is to start with an inspiration piece. This can be a fabric that you love that has several colors in it. Simply choose fabrics that coordinate with your inspiration fabric and include all of your favorite colors. Then you can add colors that may not be in the inspiration fabric, but that complement it. This can take quite some time, so give yourself plenty of shopping time to find the pieces of fabric to create your quilt. Often it's a process of trying many different pieces, taking some out and trying again. Always remember to look at your fabrics from a distance. Since your quilt will most likely not be viewed from a few inches away, step back and see how your colors look from across the room. That will give you a good visual of how the fabrics will look in the quilt.

Once you have your fabrics selected, look to see that you have variations in value. The value refers to how light or dark a color is. Most quilt designs emerge from the differences in value between the pieces. If you don't have light, medium, and dark values, the pieces will all blend together and you'll lose the design completely.

Finally, be sure you have a variety of scale in your prints. By scale I mean how small or large the motif on a print is. Including small-, medium-, and large-scale prints can really give movement and life to your quilt. Don't be afraid to use some really large-scale prints even if you're going to cut them up into small pieces. The look you get will be very unique and interesting.

I often like to include some geometric fabrics in my quilts. I love plaids, stripes, and polka dots, and you'll see them used extensively in these quilts. They create a nice variety in the visual texture of your quilt.

Rotary Cutting

Gone are the days of cutting fabric using templates and scissors. The rotary cutter has made this step quick and accurate. You'll need a rotary cutter, a self-healing mat that measures at least 24" in one direction, and an acrylic ruler that is at least 24" long. A second acrylic ruler in a smaller, square size (such as a Bias Square®) also comes in handy for making cleanup cuts when cutting strips and small pieces.

1. Press your fabric and fold it as it comes off the bolt—that is with the selvages aligned. Place the fabric on the cutting mat with the folded edge toward you. Square up the raw edge by aligning a small ruler along the folded edge of the fabric. Place the large ruler to the left, butting it up against the small ruler as shown.

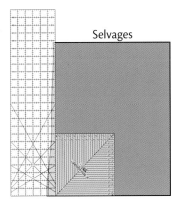

2. Remove the small ruler and cut along the right edge of the large ruler. This first cut is called a cleanup cut since it removes the fabric's ragged edges.

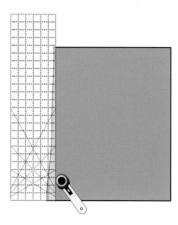

3. To cut strips, position the large ruler so the desired measurement is aligned with the newly cut edge of the fabric.

4. Strips can then be crosscut into squares or rectangles. Place the strip horizontally on the cutting mat. Trim off the selvages and square up the end using two rulers as described in steps 1 and 2. Align the proper measurement on the ruler with the newly cut edge of the fabric. Cut the strip into the desired number of squares or rectangles.

5. Triangles are cut from squares by cutting them either once or twice on the diagonal. Both result in 90° (right-angle) triangles, but with the stretchy bias grain on different edges. Cutting a square once diagonally results in two half-square triangles, while cutting twice diagonally results in four quarter-square triangles.

Machine Piecing

The patterns in this book are based on sewing a ¼"-wide seam allowance. In order for the adjoining pieces to fit together properly, you need to be very accurate with your seam allowance. Use a guide on your sewing machine for the best results. This guide can be a special piecing foot that measures exactly ¼" from the edge of the foot to the needle. An alternative is to create a guide on the bed of the machine by using a small ruler to measure ¼" from the needle and placing a piece of masking tape at this point.

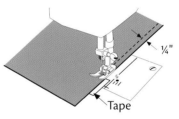

Tape

Once you've established a guide, I recommend doing a sewing test to be sure you get the proper results. It's more important that the piece you're stitching measures the proper size when finished than that the seam allowance measure ¼". In fact most quilters find that a scant ¼" (a few threads less than ¼") gives the best result since a few threads are lost in the fold when the pieces are pressed.

To test your seam allowance, cut three 1½" x 3" fabric strips. Sew them together along the long edges. Press the seam allowances to one side. The resulting unit should measure 3½" across. If your unit does not measure 3½", make some adjustments and try again. For a unit that is too small, use a slightly narrower seam allowance. If the unit is too big, make your seam allowance a little wider.

3½"

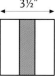

Pressing

In quilting, seam allowances are generally pressed to one side. Once a seam is stitched, lay the piece on the ironing board and press the seam flat from the wrong side with a hot, dry iron. Next open the unit and press the seam allowances in the desired direction from the right side, with the edge of the iron along the seam line. Hold the iron in place; too much movement can distort the piece. Pressing from the right side in this manner prevents tucks from forming at the seam line.

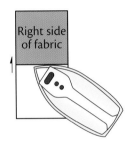

Right side of fabric

Throughout this book you'll find arrows in the block illustrations that indicate the direction for pressing the seam allowances. This choice is based on construction and/or ease of pressing. When the block is complete, I like to use steam in my iron to give it a final press. The block can also be misted with water and pressed flat. Flat blocks result in flat quilts, so this is a good step to take.

Hand-Appliqué Techniques

Hand appliqué is a portable technique that allows you to take your quilting "on the go." In this section I describe my favorite method, but feel free to use any method you prefer.

Preparing the Background

As you appliqué, the edges of your block sometimes get frayed or pulled out of shape, so you will cut the background fabric ½" to 1" larger than your unfinished block. When the appliqué is complete, trim your block to the proper size. Establish centering lines on your block by folding it in half and finger-pressing the crease. Open it up, fold it in half again in the opposite direction, and finger-crease. Never use an iron to press these creases or they may be difficult to remove later.

You may need a guide to establish the position of the appliqué pieces. I like to use overlays made from clear plastic (plastic page protectors work great!) or tracing paper. Draw the design on the overlay using a permanent marker. Position the overlay on top of the background. Slip the individual appliqué pieces under the overlay into position and pin in place. An alternative is to lightly trace the design on the background using a pencil or washable marker.

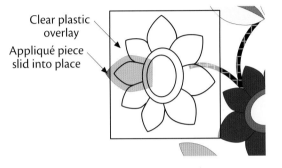

Clear plastic overlay

Appliqué piece slid into place

Preparing Freezer-Paper Appliqué Pieces

You'll need to prepare a freezer-paper template for each appliqué piece. The waxy (shiny) side of the freezer paper can be ironed onto the fabric and removed cleanly when the stitching is completed. For any asymmetrical pattern piece, you will need to make the freezer-paper template in reverse so that the appliqué will be oriented correctly when you stitch it to the background.

1. Trace the appliqué shape onto the paper (dull) side of the freezer paper. Cut out the template directly on the drawn line. You can cut multiple layers by stapling up to four layers of freezer paper together.

2. Press the waxy side of the freezer paper to the wrong side of the fabric with a dry iron. Leave approximately ¼" seam allowance around each piece. Try to place curved edges on the bias because this will make it easier to turn under the edges.

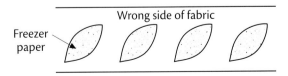

Wrong side of fabric

Freezer paper

3. Cut out each shape leaving a scant ¼" seam allowance.

Preparing Circles

To make perfect circles, start by making a template cut to the exact size of the required circle from cardboard or heat-resistant plastic. You can purchase heat-resistant circle templates at quilt shops and via the Internet. Cut the fabric about ½" larger than the circle template to create a ¼" seam allowance. Sew a small gathering stitch around the outside edge of the fabric circle within the ¼" seam allowance. Place the circle template in the center and gently pull up the gathering stitches.

Spray some starch into a cup and use a small paintbrush or a cotton swab to apply the starch to the gathered seam allowance. Using the gathering thread, pull the fabric tight around the circle and press with an iron until the starch is completely dry. Turn the circle over to the right side and press again. Loosen the gathering stitches and remove the plastic. Pull the gathering thread lightly to re-form the circle, and then clip off the thread. The edges are perfectly turned under and the circle is ready to be appliquéd.

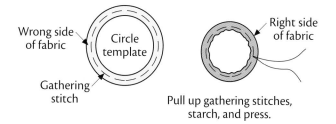

Wrong side of fabric

Circle template

Gathering stitch

Right side of fabric

Pull up gathering stitches, starch, and press.

Preparing Stems

Stems that curve must be cut on the bias grain of the fabric to have the necessary stretch. Follow the directions in step 1 of "Binding Your Quilt" on page 12 to cut bias strips. Cut strips for straight stems along the straight grain of the fabric as usual. For stems, cut ⅞"-wide strips as needed; join the strips, if necessary, to achieve the desired length. Press the seam allowances open. Along one long edge, press a little more than ¼" to the wrong side as shown. Fold the remaining long edge in the same way and press or baste in place using long basting stitches. The stem is now its finished width and ready to appliqué.

Basic Needle-Turn Appliqué

1. In general, you'll work from the *bottom up* when placing and appliquéing the pattern pieces. In other words, a piece partially hidden beneath another shape will be appliquéd first. Position your first piece and pin it in place. I like to place several small pins in the seam allowance around the piece. With pieces adhered to freezer-paper templates, you can peek under the fabric to see if the template is positioned exactly where you want it.

2. Thread your needle with a thread color that matches the appliqué piece. I like to use a size 10 or 11 straw needle (a long, strong needle) and silk thread. The very fine thread blends into the fabric so well that the stitching is hardly noticeable. Use your needle to turn the seam allowance under where you want to start sewing. The freezer paper on the wrong side provides a guide for the edge and prevents you from turning under too much seam allowance. Hold the seam allowance in place with your non-sewing hand. Bring your needle up from the back, through the background and through the fold on the edge of the appliqué piece. Take your needle back down into the background only, at exactly the point where it came up through the fold of the appliqué. Move the needle horizontally along the back and come up ¹⁄₁₆"– ⅛" from the previous stitch, through the background and the fold on the edge of the appliqué. Continue stitching around the piece, holding the appliqué with your non-sewing hand and turning the seam allowance under with the needle as you go. You do not need to turn under edges that will be overlapped by another appliqué piece; these raw edges will be covered by the next piece. Finish stitching

each piece by making a few backstitches on the back.

3. Remove the freezer-paper templates by carefully cutting a slit in the background fabric behind the appliqué. Be careful to cut only the background fabric and not through the freezer paper. If you wish, you can cut out the background fabric, leaving a ¼" seam allowance inside the appliqué stitches. Gently tug on the freezer paper to loosen it and remove it.

Wrong side of background

4. When all the appliqué is complete, place your block right side down on a fluffy terry-cloth towel (to prevent the appliqué from flattening out) and press using a bit of steam. Finish by trimming your block as directed.

Needle Turning Curves and Points

Inside Curves. Pieces with inside curves need to be clipped for the seam allowance to turn smoothly. Use sharply pointed scissors and make several clips along the curve about halfway into the seam allowance. The sharper the curve, the more clips you will need.

Inside Points. Clip inside points three to four threads short of the freezer-paper template. When your stitching approaches the point, use your needle in a sweeping motion to turn under the seam allowance along the edge. Continue stitching until you reach the point, and then take a slightly deeper stitch of three or four threads. Bring your needle back down into the background, slightly under your appliqué piece, and pull the needle through from the back. This motion will tuck under those three or four threads at the point. Bring the needle back up through the background and into the fold of the appliqué; continue stitching around the piece.

Make 1 stitch,
3 to 4 threads deep.

Outside Points. Make sharp outside points by stitching right up to the point and taking the last stitch exactly at the point. Trim any excess seam allowance that peeks out the other side as shown. Turn the seam allowance under at the point, and then turn under the edge along the next side of the shape. Take a small tug on the thread, which will pull the point out sharply. Hold with your non-sewing hand and continue sewing the next side.

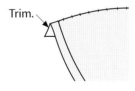

Trim.

Fusible Machine Appliqué

I love to use machine appliqué on simple shapes and when I want the folksy look of buttonhole stitching. You'll need paper-backed fusible web. There are many fusible-web products on the market, but I prefer a lightweight product suitable for quilting. When you purchase a fusible-web product, take time to read the manufacture's directions.

1. Trace the appliqué shape onto the paper side of paper-backed fusible web. If the shape is asymmetrical, be sure to trace the design in reverse so the appliqué will be oriented correctly when fused to the background.

2. Roughly cut the shape out of the fusible web, leaving about ¼" all around the drawn line. Fusible web can make the appliqué shapes somewhat stiff. To prevent this, you can cut out the center of the fusible-web shape leaving at least ¼" inside the drawn line. (This trimming allows the shape to adhere to the background while eliminating the stiffness within the shape.)

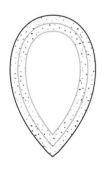

3. Place the shape, fusible-web side down, on the wrong side of the appropriate appliqué fabric. Following the manufacturer's directions, iron in place. Cut out the fabric shape on the drawn line.

Wrong side of fabric

4. Using your pattern as a guide, position the appliqué shape, adhesive side down, on the right side of the background fabric and press.

5. Finish the edges with a decorative stitch, such as a machine blanket stitch, in a thread color that matches the appliqué piece (or try black thread for a folk-art look). Set your machine to make a blanket stitch, adjusting the width and length to about ⅛" each. Stitch along the edge of the appliqué so that the straight stitches are in the background, very close to the appliqué edge, and the swing stitches are in the appliqué piece. For curves and points, stop with the needle in the down position, in the background, and pivot.

Blanket stitch

Adding Borders

To finish with a quilt that is flat and squared at the corners, your borders must be of equal lengths on opposite sides. If a quilt is even ½" larger on one side than the other, it's no longer a truly square or rectangular quilt. Since the edges of the quilt center may not be the same measurement once the blocks are sewn together, attaching a border and trimming it will almost *guarantee* that the opposite borders are not the same length. You can measure across your quilt center and cut the two opposite plain borders to that measurement, but since it is so easy to make mistakes in measuring, I use the following method to trim my borders to length instead. You've probably heard the saying "Measure twice, cut once." I have found that a better rule is not to measure at all.

1. Piece the border strips together end to end, if necessary, to create two borders that are several

inches longer than the sides of the quilt. Place the quilt top flat on a table or on the floor and lay two border strips together down the center of the quilt. Using a rotary cutter, ruler, and cutting mat, trim the two borders even with the raw edges of the quilt. You now have two border strips that are equal to each other and to the quilt center without having taken any measurements!

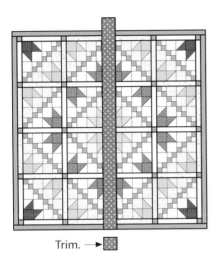

Trim. →

2. Find the center points of the border strips and the quilt center by folding them in half and marking with a pin. Place one border strip on each side of the quilt, matching the ends and the center points. Pin the borders in place and sew them to the quilt center with a ¼" seam allowance. You may need to ease the border strips or the quilt center a bit to make them fit, but it's easy to do so over this long side of the quilt. In most cases, you'll want to press the seam allowances toward the border.

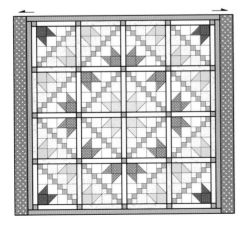

3. Repeat step 1 with the top and bottom borders, placing them across the quilt center and trimming them even with the raw edges of the quilt top, which now includes the side borders. Sew these borders to the top and bottom of the quilt. I like to take a few backstitches at each end on these last two seams of the quilt to prevent the seam from coming apart during quilting.

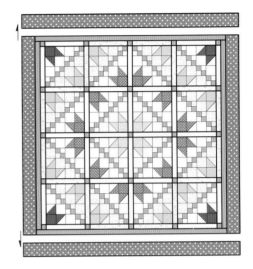

Pieced Borders

Pieced borders add a lot of interest to your quilt, but require some special attention. You'll notice in the instructions that when a plain border is sewn to the quilt center prior to adding a pieced border, the plain border needs to be cut a specific length. It's important that the length of the plain border be very accurate so that the pieced border will fit properly. Cut your plain borders to the specified length and ease them on the quilt if necessary. (I've indicated the correct measurement of the quilt center, including seam allowances, after adding the plain border.)

When adding the pieced border to your quilt, accuracy in piecing is extremely important. This type of border has many seams where inaccuracies can add up. To ensure that pieced borders are the proper length, I piece the border in segments, sewing two or three units at a time. Then I measure the finished size of the units to be sure that they are the correct size. If necessary, I can make adjustments in my seam allowance before the entire border is sewn together. To determine the correct size of the units, subtract ½"

from the quilt center's correct measurement and then divide the resulting number by the number of units in the pieced border. For example, if the quilt center is 60½" and there are 12 units in the pieced border, the finished size of each unit is 5". Your calculation would look like this: 60½" - ½" = 60 ÷ 12 = 5".

Measure from seam to seam for finished length.

Binding Your Quilt

I like to use French double-fold binding on my quilts. This folded binding is easy to apply and gives a double layer of fabric that wears well. I generally cut the binding strips 2½" wide, but they can be cut slightly narrower or wider depending on the look you want. Yardage calculations for the binding of the quilts in this book are based on 2½"-wide strips.

The binding can be on the straight grain or on the bias. For straight-grain binding, cut the strips selvage to selvage. I like to cut the binding on the bias when I'm using a striped or a plaid fabric because I like the look of the diagonal line around the edge of the quilt.

Before attaching binding to your quilt, use your rotary cutter and ruler to trim the borders of the quilt so they are straight, even, and square at the corners. You will be trimming the backing and batting even with the quilt top at the same time.

1. Cut enough strips so that you have a length equal to the perimeter of the quilt plus 10". To cut strips on the straight grain, refer to "Rotary Cutting," steps 1–3 on page 5. To cut bias strips, open the fabric to one layer and press flat. Place the fabric on a cutting mat and position your long acrylic ruler on the fabric so that the ruler's 45° line is on the fabric's selvage edge. Cut along the edge of the ruler to establish the 45° angle. From the newly cut edge, cut as many 2½"-wide

strips as required. Trim the ends of the strips square.

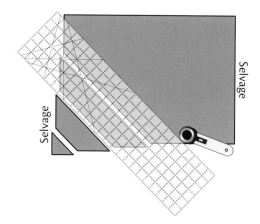

2. Place the ends of two strips (either straight-grain or bias) right sides together at right angles and draw a diagonal line as shown. Sew directly on the line. Continue to join the remaining strips in the same manner. Trim the seam allowances to ¼" and press the seam allowances open.

3. Fold the strip in half lengthwise with wrong sides together and press.

4. Place the raw edge of the binding strip even with the raw edge of the quilt. Using a walking foot if possible, begin sewing the binding to the quilt with a ¼" seam allowance, leaving about 10" free at the starting end. Sew to the first corner, stopping ¼" from the corner; backstitch.

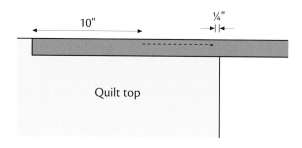

Quilt top

5. To miter the corner, remove the quilt from the machine and turn the quilt so you will be ready to sew the next edge. Fold the binding straight up and away from the quilt so the fold forms a 45° angle.

6. Fold the binding back down, aligning the fold with the top raw edge of the quilt and the raw edges of the binding with the raw edge of the quilt's second side. Beginning at the fold, continue sewing the binding to the quilt, mitering each corner as you come to it.

7. Stop stitching about 10" from the starting end of the binding strip. Place the quilt on a flat surface and overlap the two ends of binding strips. Trim the overlap equal to the original cut width of the binding, which in this case is 2½".

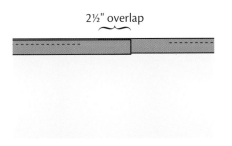

2½" overlap

8. Place the beginning and ending tails right sides together at right angles. Draw a diagonal line as you did in step 2. Pin and stitch on the line.

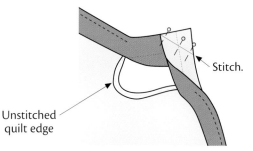

Stitch.

Unstitched quilt edge

9. Check to be sure the binding fits correctly. Trim the seam allowances to ¼" and finger-press them open. Pin the binding in place and finish stitching it to the quilt.

10. Fold the binding over the edge of the quilt to the back. Blindstitch the binding to the quilt back using a thread color that matches the binding. Miters will form at the corners.

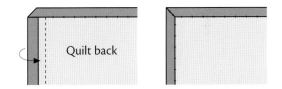

Quilt back

For many years I've had the idea of using historic botanical prints as inspiration for quilt design. This quilt is the result of that inspiration. Created using actual photographs, antique botanical prints, and real flowers from my garden, these designs are my quilted interpretation of botanical art. I've even inked the Latin botanical names on the blocks for authenticity.

Flower Garden

Materials

Yardage is based on 42"-wide fabric.
Fat quarters measure 18" x 21".

1⅝ yards of yellow polka-dot fabric for blocks

1⅜ yards of green solid fabric for sashing, pieced border, and appliqués

1¼ yards of cream tone-on-tone fabric for block backgrounds

1¼ yards of black-and-green plaid for pieced border and binding

1 yard of green print for blocks

¾ yard of black solid fabric for blocks

3 fat quarters of assorted green fabrics for stem and leaf appliqués

Assorted scraps of blue, yellow, red, eggplant, black, and pink prints for flower and insect appliqués

4¼ yards of fabric for backing

70" x 70" piece of batting

Fine-point black permanent marking pen

Black embroidery floss (optional)

Cutting

Cut all strips across the width of the fabric unless otherwise noted.

From the cream tone-on-tone fabric, cut:

3 strips, 13" x 42"; crosscut into 9 squares, 13" x 13"

From the *straight grain* of the 3 fat quarters of assorted green fabrics, cut:

Enough ⅞"-wide strips to total approximately 30"

From the *bias* of the 3 fat quarters of assorted green fabrics, cut:

Enough ⅞"-wide strips to total approximately 120"

From the green print, cut:

2 strips, 6¼" x 42"; crosscut into 9 squares, 6¼" x 6¼". Cut each square twice diagonally to yield 36 quarter-square triangles.

4 strips, 4" x 42"; crosscut into 36 squares, 4" x 4"

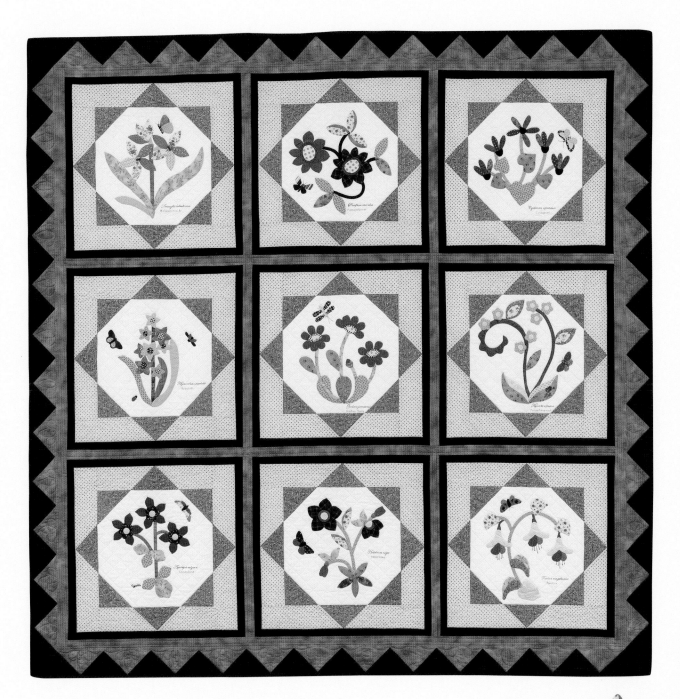

Finished quilt: 65½" x 65½"

Finished block: 17" x 17"

Pieced, appliquéd, and machine quilted by Cindy Lammon

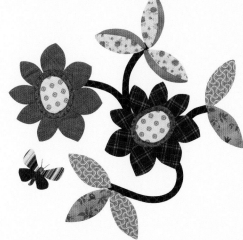

From the yellow polka-dot fabric, cut:

9 strips, 3" x 42"; crosscut into 36 rectangles, 3" x 9⅜". Place 2 rectangles wrong sides together and trim one end at a 45° angle. Repeat with the remaining pairs of rectangles to yield 18 trapezoids and 18 reversed trapezoids. (See box at right.)

8 strips, 3" x 42"; crosscut into 36 rectangles, 3" x 6⅞". Place 2 rectangles wrong sides together and trim one end at a 45° angle. Repeat with the remaining pairs of rectangles to yield 18 trapezoids and 18 reversed trapezoids. (See box at right.)

From the black solid fabric, cut:

18 strips, 1¼" x 42"; crosscut into:
- 18 rectangles, 1¼" x 17½"
- 18 rectangles, 1¼" x 19"

From the green solid fabric, cut:

2 strips, 6¼" x 42"; crosscut into 12 squares, 6¼" x 6¼". Cut each square twice diagonally to yield 48 quarter-square triangles.

7 strips, 1¾" x 42"

6 strips, 1½" x 42"; crosscut *3 of the strips* into 6 rectangles, 1½" x 19"

From the black-and-green plaid, cut:

2 strips, 6¼" x 42"; crosscut into 11 squares, 6¼" x 6¼". Cut each square twice diagonally to yield 44 quarter-square triangles.

2 squares, 5⅞" x 5⅞"; cut once diagonally to yield 4 half-square triangles

7 binding strips, 2½" x 42"

CUTTING TRAPEZOIDS

Trapezoids can easily be cut from rectangles. Find the 45° line on your ruler. Place that line on the long edge of a rectangle starting at the corner, as shown. Trim along the edge of the ruler. By layering two rectangles wrong sides together you'll end up with mirror-image trapezoids!

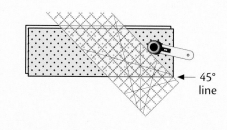

45° line

Appliquéing the Blocks

Refer to "Hand-Appliqué Techniques" on page 7 for guidance as needed.

1. Fold each 13" cream square in half in both directions and finger-press to establish centering lines.

2. Referring to "Preparing Stems" on page 8, use the ⅞"-wide assorted green strips to prepare the required length of straight-grain and bias stems as described in the cutting list. As you make the blocks, cut curved stems from the prepared bias strips and straight stems from the prepared straight-grain strips.

3. Working one block at a time, use the patterns on pages 20–37 and the assorted blue, yellow, red, eggplant, black, and pink scraps to prepare the flower petals, flower centers, and insects for each block. From the remaining assorted green fabrics, prepare the leaf appliqués for each block. Refer to the photo on page 15 for color guidance as needed.

4. Continuing to work one block at a time, refer to the pattern for each block to position the appliqué shapes on the 13" cream squares. Appliqué the pieces in numerical order as indicated on the pattern.

APPLIQUÉING TINY SHAPES

Don't let the small insects scare you! (Appliquéing them, I mean!) They really aren't as difficult as you might think. The trick is to just turn under a bit of fabric at a time. Use your needle to turn under a small amount of seam allowance. Take one stitch and turn under a little more seam allowance. Continue around the shape a stitch at a time. Draw in the details and you'll have a friendly little insect.

5. Use a permanent marker and a light box to trace the Latin and the common name for each flower onto the background. Trace or embroider the flower and insect details.

6. Make nine blocks. Gently press, and then trim each block to 12½" x 12½", making sure to keep the appliqué centered in the block.

Piecing the Blocks

Directions are for one block. Repeat to make a total of nine blocks. After sewing each seam, press the seam allowances in the direction indicated by the arrows.

1. Use your preferred marker and a ruler to draw a line from corner to corner on the wrong side of four 4" green squares.

2. With right sides together, place a marked square on each corner of an appliquéd block, noting the direction of the line. Sew on the marked line. Trim the excess fabric, leaving a ¼" seam allowance.

3. With right sides together, sew a 3" x 6⅞" yellow trapezoid and a reversed yellow trapezoid to each short side of a green print triangle as shown. Make two.

PERFECTLY PIECED TRAPEZOIDS

Lining up the trapezoid and the triangle can be tricky. You can "eyeball" it by positioning the pieces so that an equal amount of excess fabric (also called "dog-ears") shows on each side. You'll notice that the valley where the pieces meet hits right on your ¼" seam allowance.

4. In the same manner, sew 3" x 9⅜" yellow trapezoids to the short sides of a green print triangle. Make two.

5. Sew the units from step 3 to opposite sides of a block from step 2. Sew the units from step 4 to the top and bottom edges.

6. Sew 1¼" x 17½" black rectangles to the sides of the block from step 5. Sew 1¼" x 19" black rectangles to the top and bottom of the block. Make a total of nine blocks.

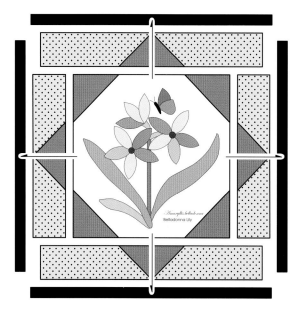

Assembling the Quilt

1. Piece the three 1½"-wide green solid strips together end to end. From this strip, cut two 58"-long horizontal sashing strips.

2. Referring to the quilt assembly diagram on the facing page, arrange the blocks, the 1½" x 19" green solid rectangles, and the horizontal sashing strips from step 1 as shown.

3. Sew three blocks and two vertical sashing strips together as shown in the assembly diagram to make a block row. Press the seam allowances toward the green strips. Make three rows.

4. Sew the rows from step 3 and the horizontal sashing strips together, alternating them as shown in the assembly diagram; press.

5. Sew three 1¾"-wide green strips together end to end. From this strip, cut two 58"-long border strips and sew them to the top and bottom of the quilt center; press. Sew the remaining 1¾"-wide green strips together in pairs and trim each strip to 60½" long. Sew the strips to the sides of the quilt center for the inner border; press. The quilt center should measure 60½" square.

6. Sew 12 green solid triangles and 11 black-and-green plaid 6¼" triangles together as shown to make a border strip; press. Make four.

Make 4.

7. Sew a triangle border strip to each edge of the quilt top as shown on the facing page. Press the seam allowances toward the green inner border. Sew a black-and-green plaid half-square triangle to each corner and press.

Finishing the Quilt

1. Layer, baste, and quilt your quilt. The quilt on page 15 was machine quilted with a diagonal grid in the background of the appliqué blocks. A feather design was quilted in the green and yellow pieces around the appliqué and in the pieced border. Straight lines were quilted in the green sashing.

2. Refer to "Binding Your Quilt" on page 12 and use the 2½"-wide black-and-green plaid strips to bind your quilt.

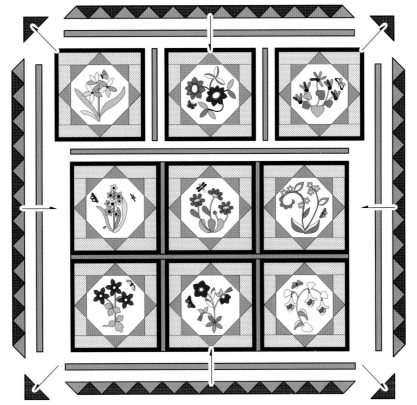

Quilt assembly

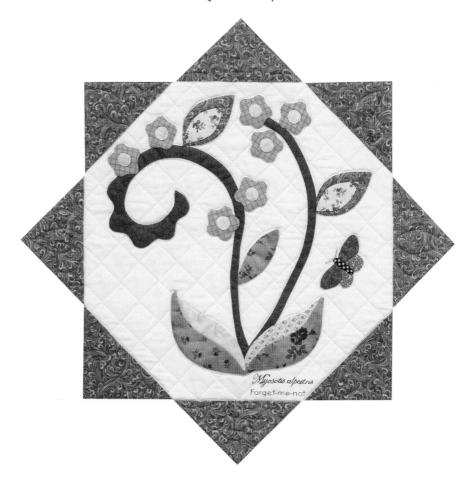

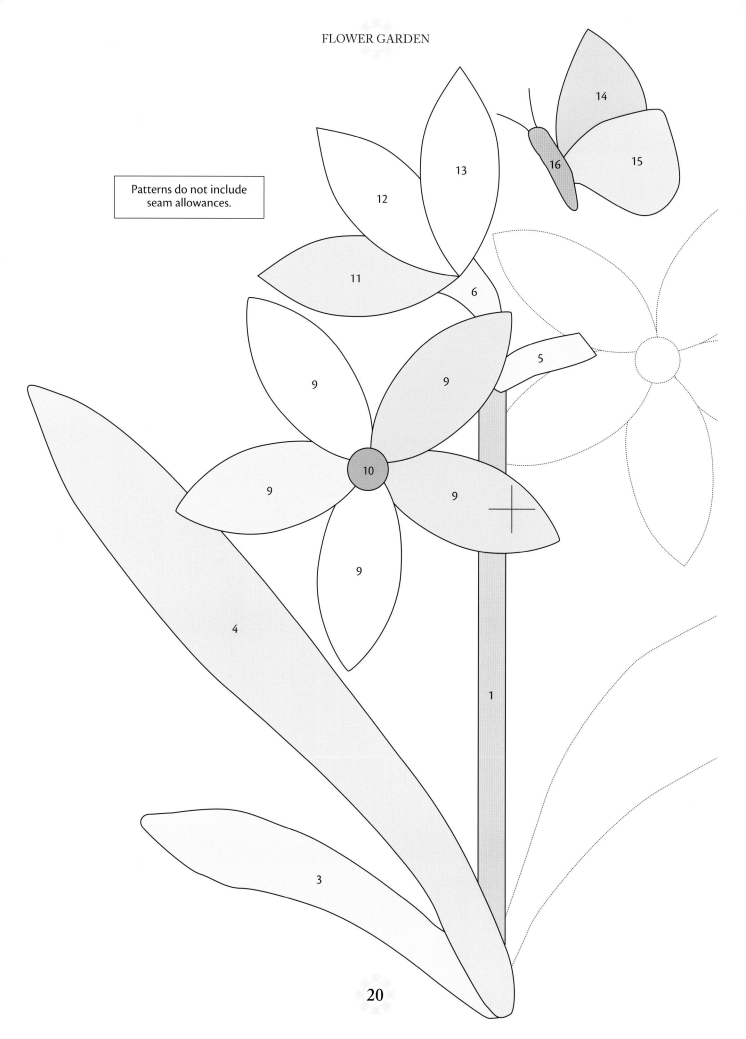

Patterns do not include
seam allowances.

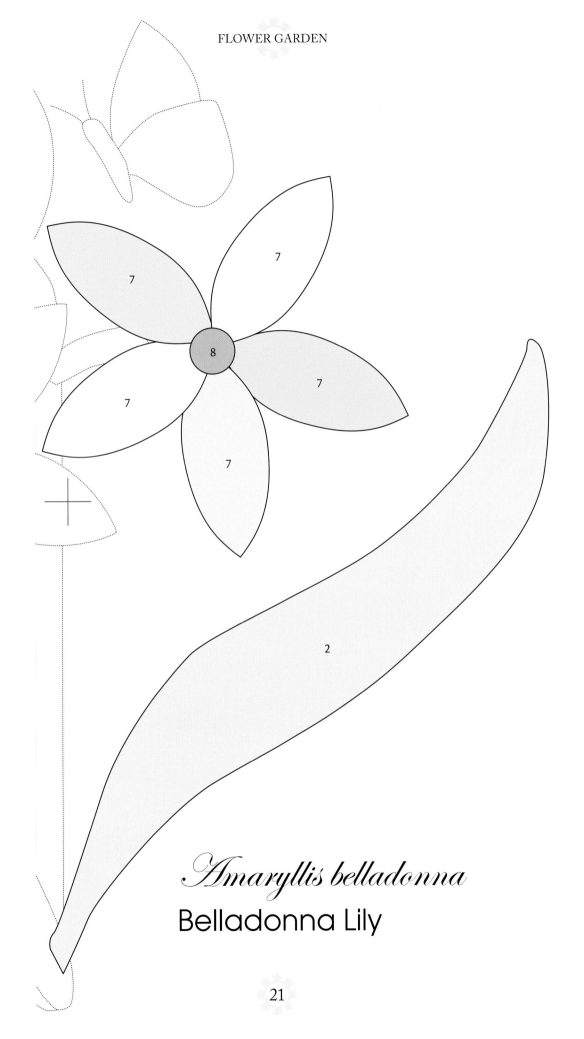

Amaryllis belladonna

Belladonna Lily

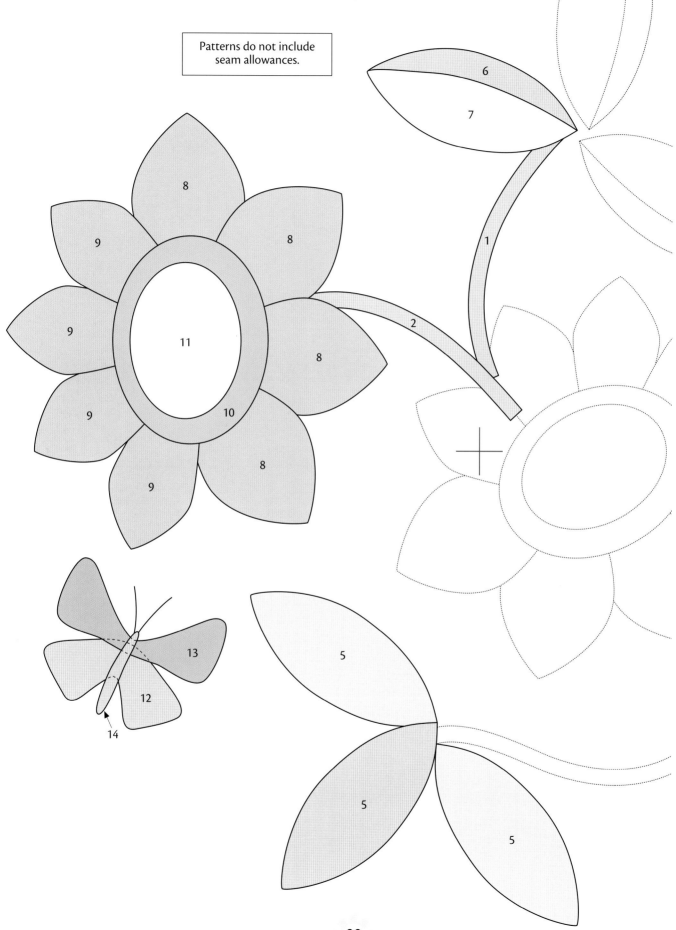

Patterns do not include
seam allowances.

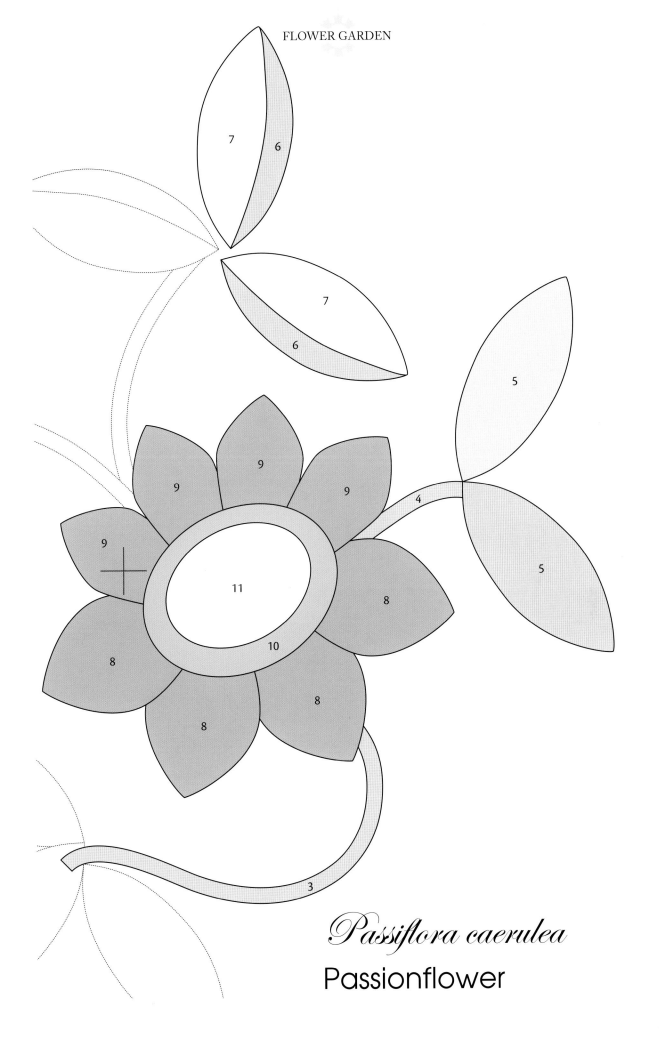

Passiflora caerulea

Passionflower

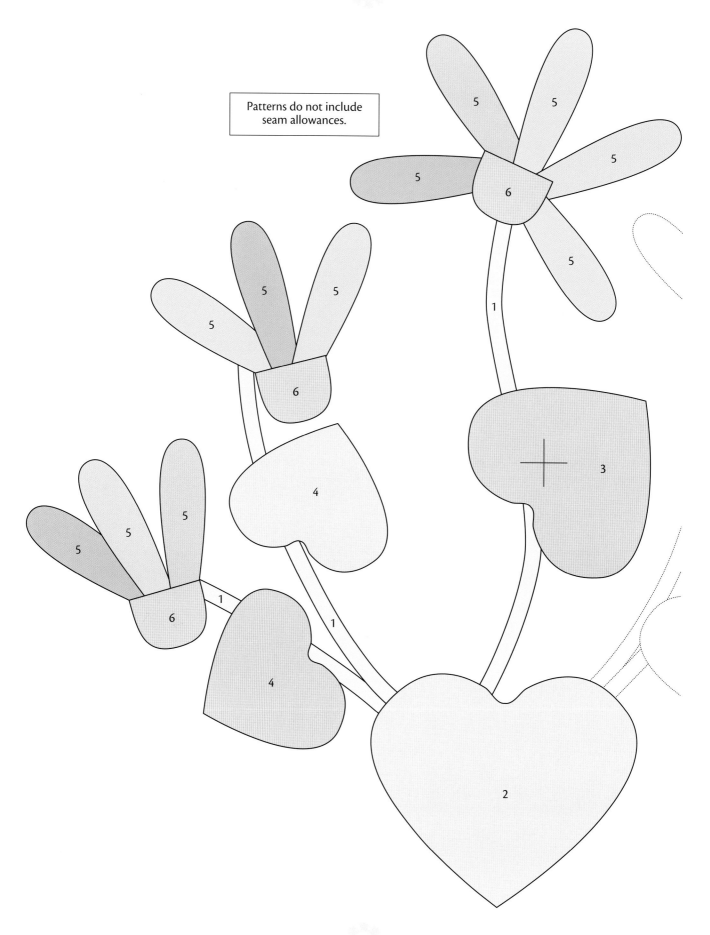

Patterns do not include
seam allowances.

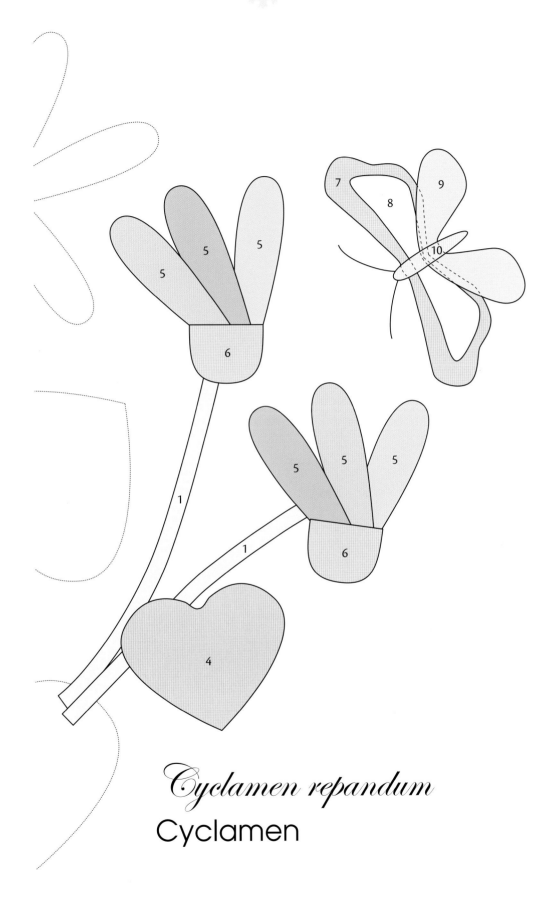

Cyclamen repandum

Cyclamen

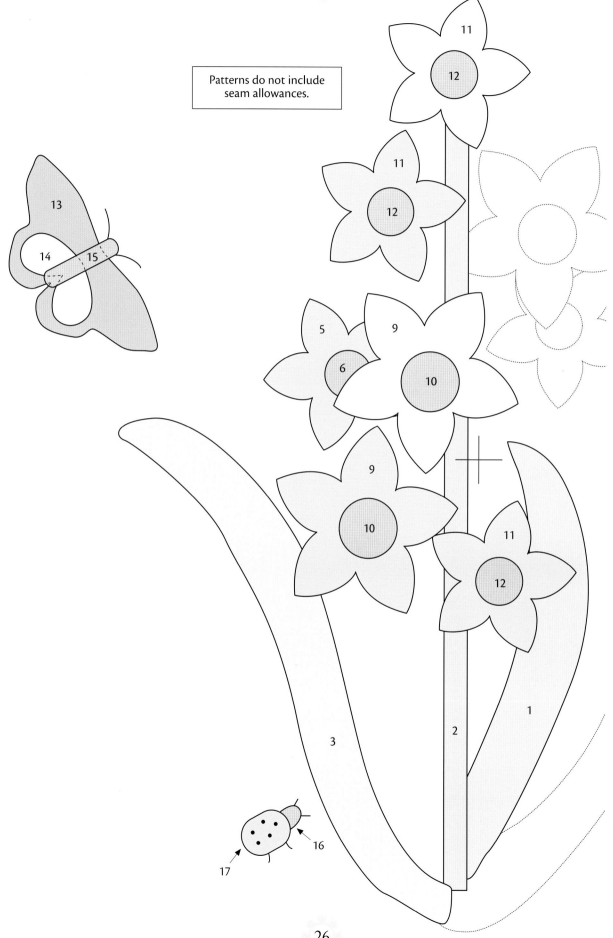

Patterns do not include
seam allowances.

26

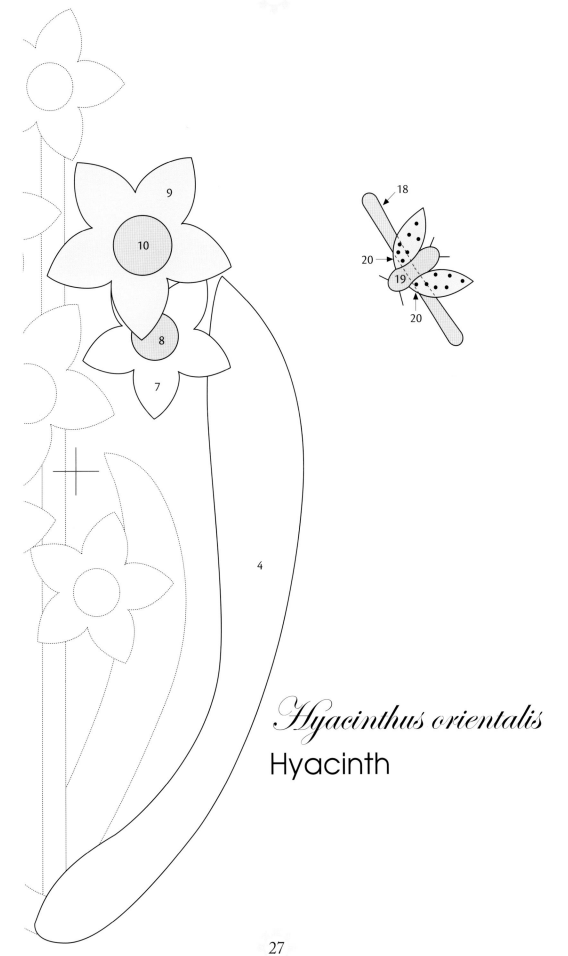

Hyacinthus orientalis

Hyacinth

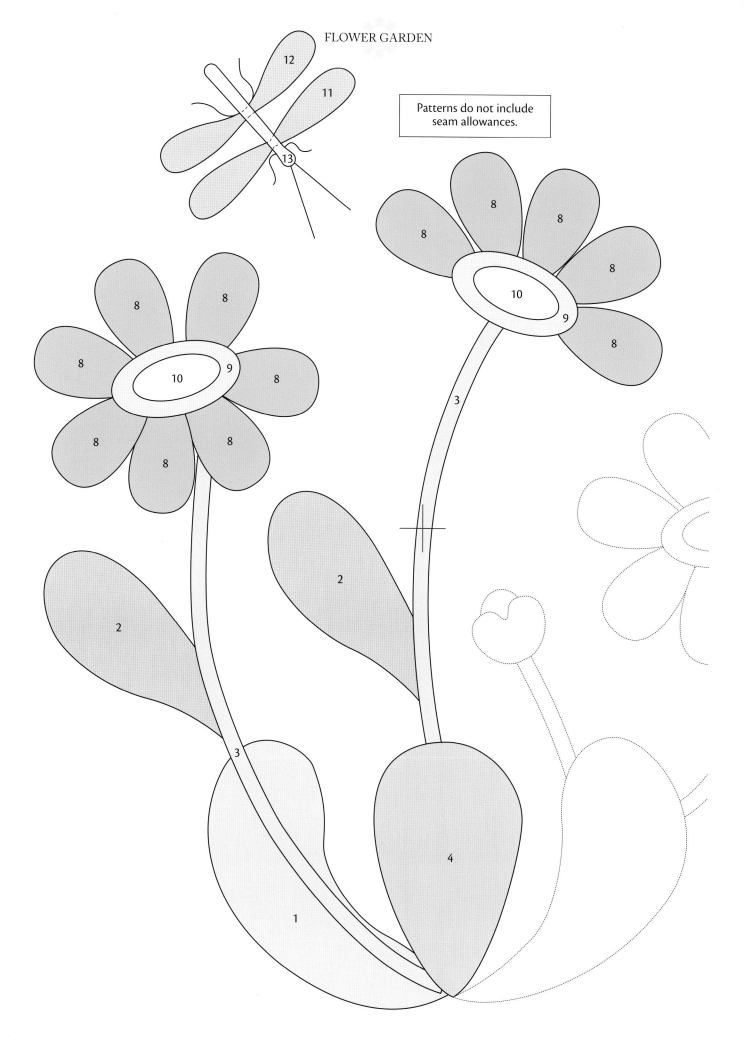

FLOWER GARDEN

Patterns do not include
seam allowances.

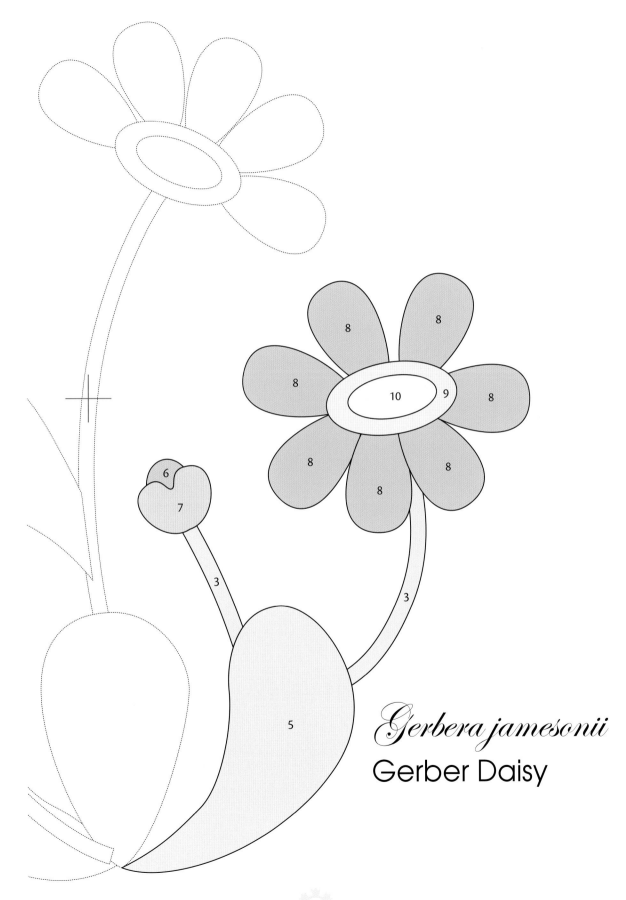

Gerbera jamesonii
Gerber Daisy

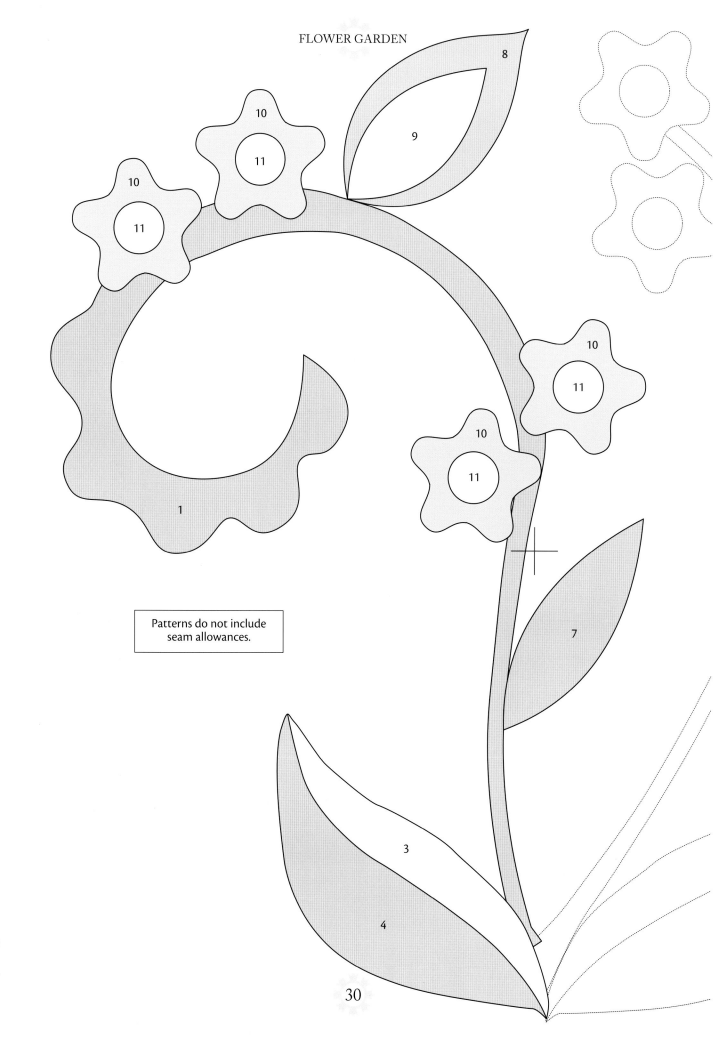

Patterns do not include
seam allowances.

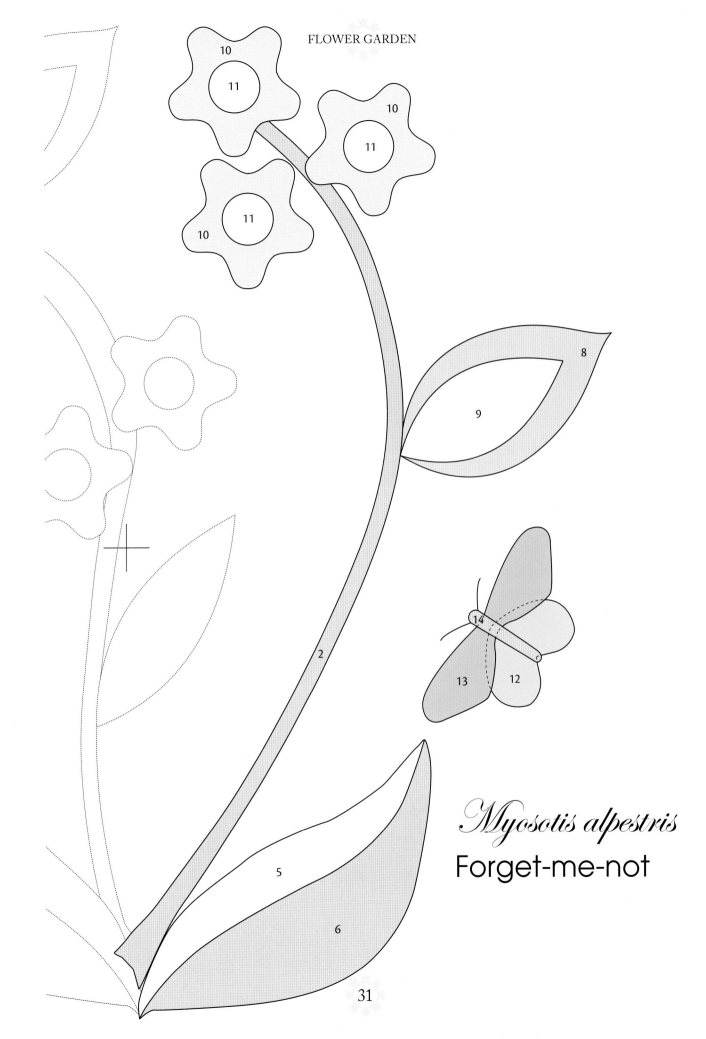

Myosotis alpestris
Forget-me-not

Patterns do not include seam allowances.

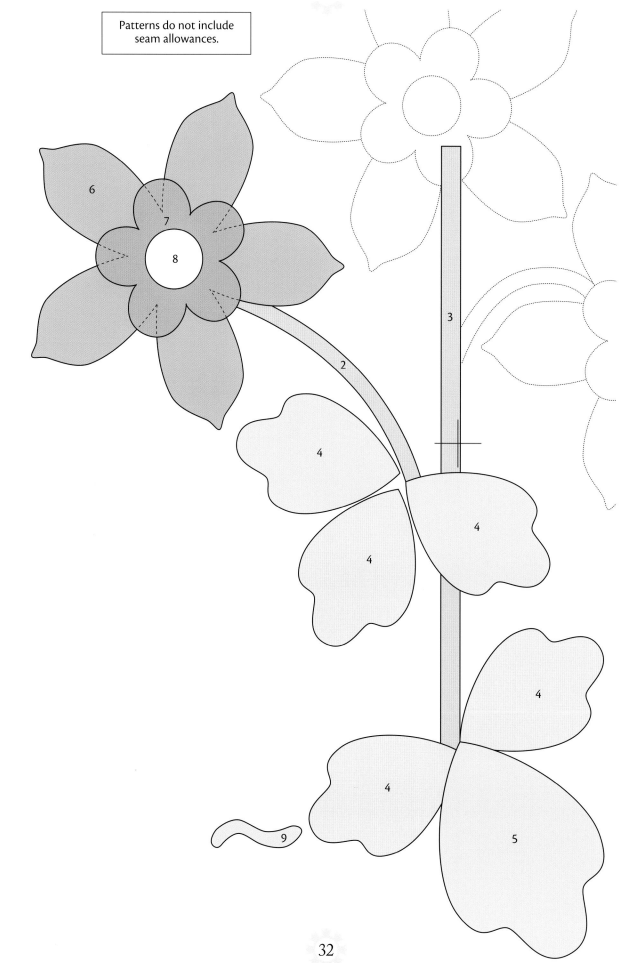

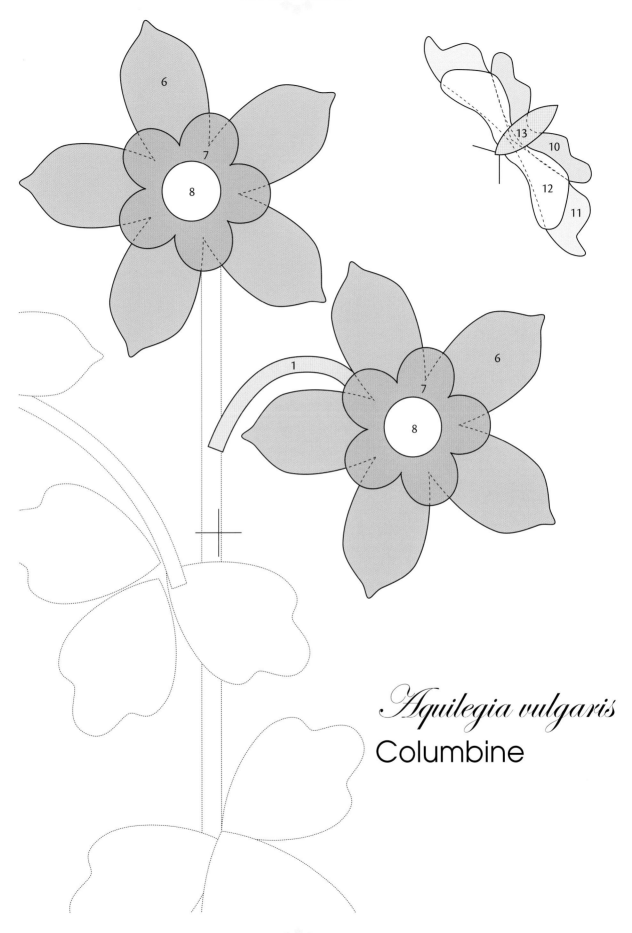

Aquilegia vulgaris
Columbine

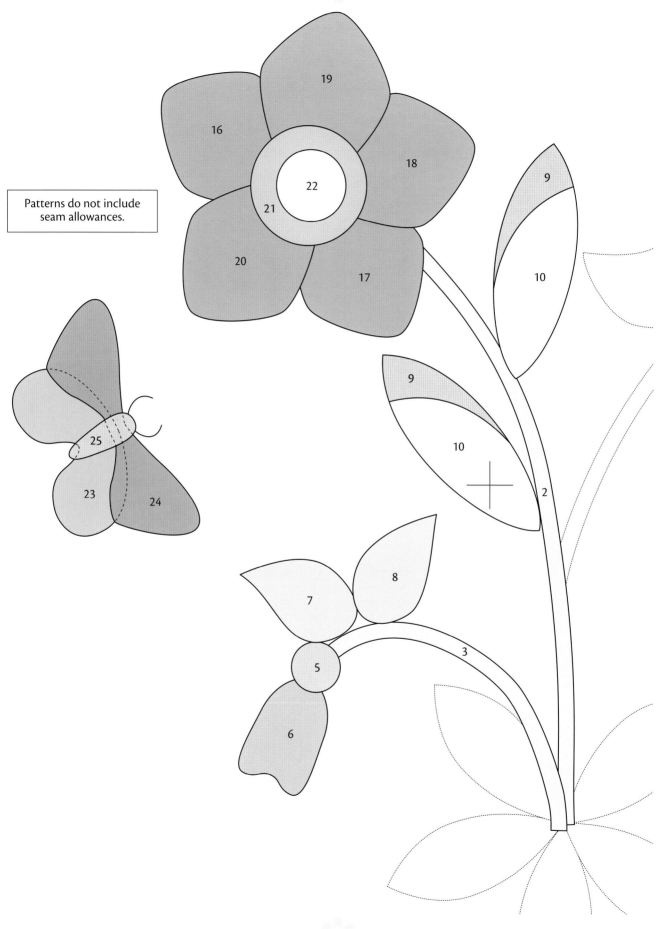

Patterns do not include
seam allowances.

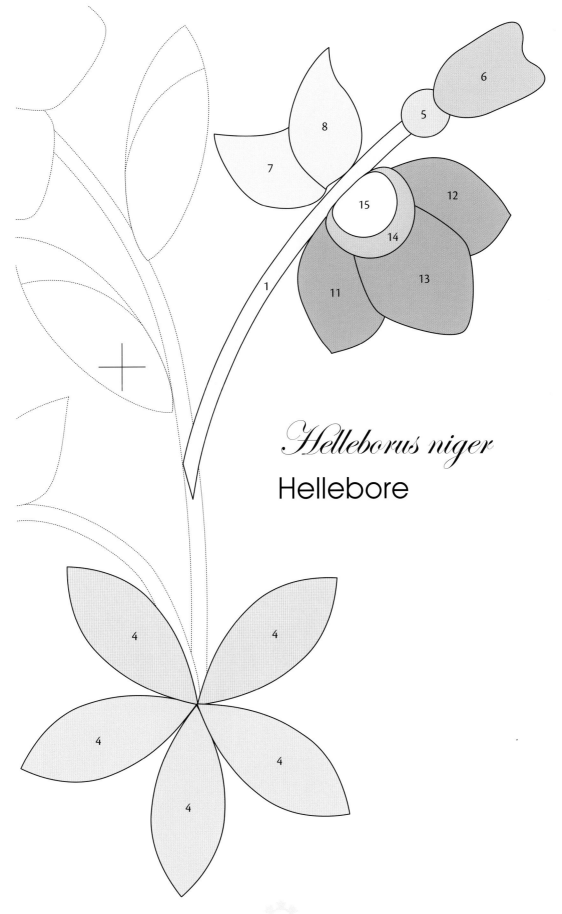

Helleborus niger

Hellebore

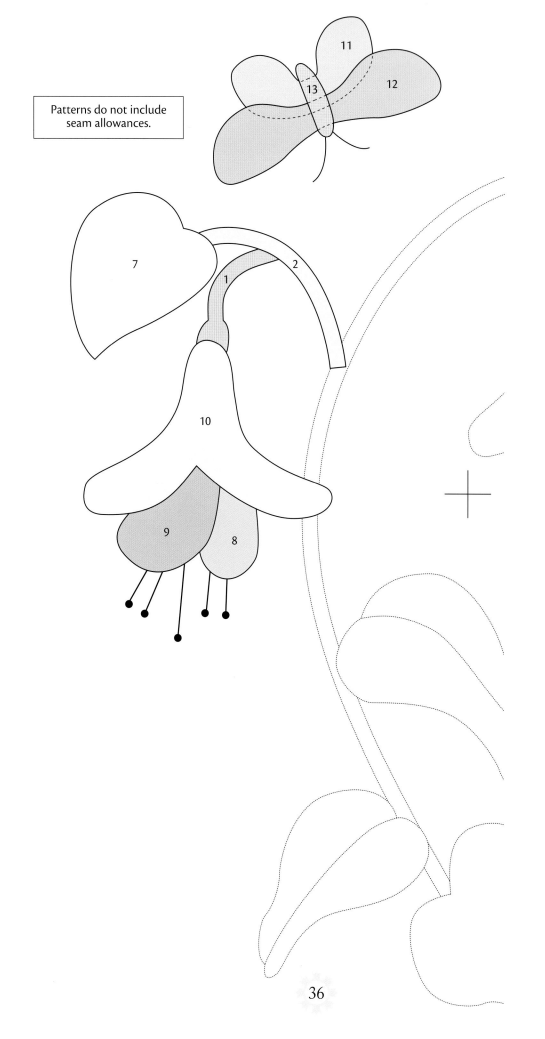

Patterns do not include seam allowances.

11

12

13

7

2

1

10

9

8

36

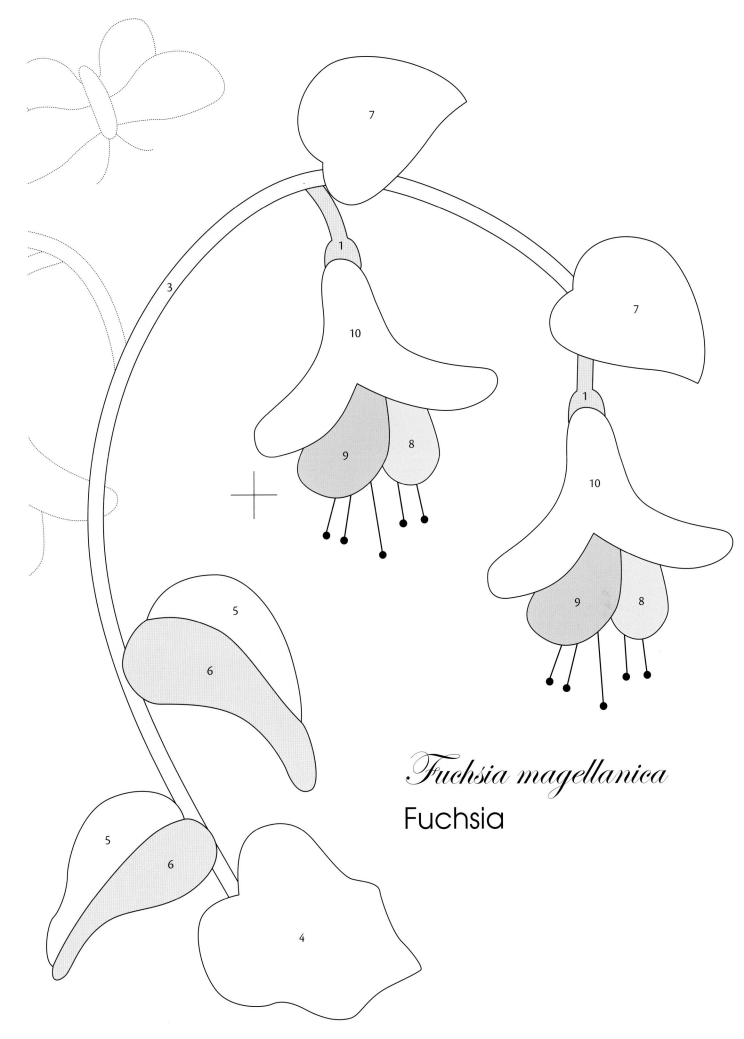

Fuchsia magellanica

Fuchsia

Tulips are one of my favorite signs of spring! Be sure to plant your tulip bulbs in the fall since they need a period of cold weather to bloom. As with all bulbs, leave the foliage intact after blooming so the bulbs can store food for the next season. If you're longing for tulips in winter, you can even "force" bulbs to bloom indoors. Or make this quilt to enjoy tulips season after season!

Tulips All Around

Materials

Yardage is based on 42"-wide fabric.
Fat quarters measure 18" x 21" and fat eighths measure 9" x 21".

1 fat quarter of pink 1 (pink tone-on-tone fabric) for blocks

2 yards of pink 2 (pink polka-dot fabric) for blocks, outer border, and binding

⅜ yard of pink 3 (pink solid fabric) for blocks

1 fat quarter of pink 4 (pink tone-on-tone fabric) for blocks

½ yard of yellow 1 (small-scale yellow print) for block backgrounds and sashing

1⅛ yards of yellow 2 (yellow tone-on-tone fabric) for block backgrounds and sashing

1¼ yards of yellow 3 (yellow-and-pink floral) for block backgrounds and sashing

⅝ yard of yellow 4 (small-scale yellow print) for block backgrounds and sashing

12 fat eighths of assorted green prints for blocks and sashing squares

½ yard of green tone-on-tone fabric for inner border

4¼ yards of fabric for backing

71" x 71" piece of batting

Cutting

Cut all strips across the width of the fabric. As you cut your fabrics, be sure to label the pieces with the fabric number. This will help you quickly identify them for piecing.

From pink 1, cut:

4 squares, 3⅞" x 3⅞"; cut once diagonally to yield 8 half-square triangles

4 squares, 3½" x 3½"

From pink 2, cut:

7 strips, 4½" x 42"

2 strips, 3⅞" x 42"; crosscut into 12 squares, 3⅞" x 3⅞". Cut each square once diagonally to yield 24 half-square triangles. From the remaining strips, cut 1 square, 3½" x 3½".

1 strip, 3½" x 42"; crosscut into 11 squares 3½" x 3½"

8 binding strips, 2½" x 42"

From pink 3, cut:

2 strips, 3⅞" x 42"; crosscut into 12 squares, 3⅞" x 3⅞". Cut each square once diagonally to yield 24 half-square triangles. From the remaining strips, cut 1 square, 3½" x 3½".

1 strip, 3½" x 42"; crosscut into 11 squares, 3½" x 3½"

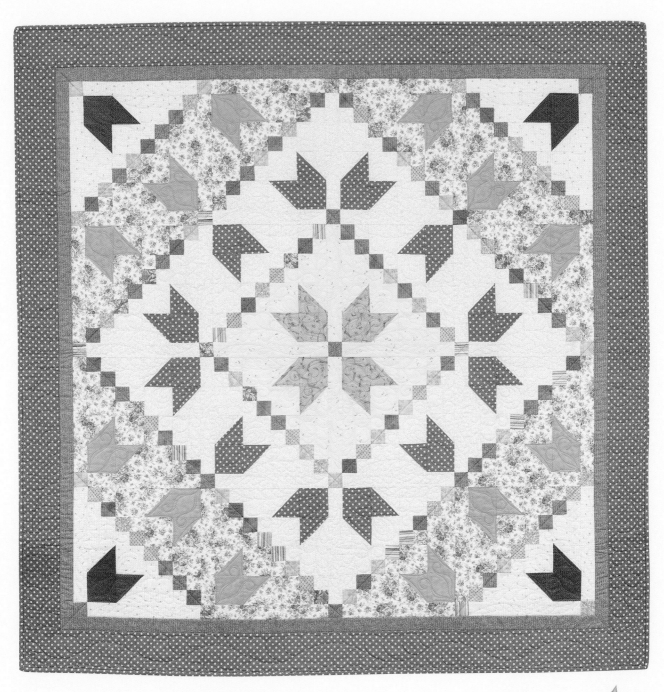

Finished quilt: 67" x 67"

Finished block: 12" x 12"

Pieced by Cindy Lammon; machine quilted by Candy Grisham

From pink 4, cut:

4 squares, 3⅞" x 3⅞"; cut once diagonally to yield 8 half-square triangles

4 squares, 3½" x 3½"

From yellow 1, cut:

1 strip, 3⅞" x 42"; crosscut into 4 squares, 3⅞" x 3⅞". Cut each square once diagonally to yield 8 half-square triangles. From the remaining strip, cut 1 square, 3½" x 3½".

1 strip, 3½" x 42"; crosscut into 11 squares, 3½" x 3½"

3 strips, 2" x 42"; crosscut into:
• 4 rectangles, 2" x 12½"
• 4 rectangles, 2" x 10"

From yellow 2, cut:

2 strips, 3⅞" x 42"; crosscut into 12 squares, 3⅞" x 3⅞". Cut each square once diagonally to yield 24 half-square triangles. From the remaining strips, cut 3 squares, 3½" x 3½".

3 strips, 3½" x 42"; crosscut into 33 squares, 3½" x 3½"

7 strips, 2" x 42"; crosscut into:
• 12 rectangles, 2" x 12½"
• 12 rectangles, 2" x 10"

From yellow 3, cut:

2 strips, 3⅞" x 42"; crosscut into 12 squares, 3⅞" x 3⅞". Cut each square once diagonally to yield 24 half-square triangles. From the remaining strips, cut 3 squares, 3½" x 3½".

3 strips, 3½" x 42"; crosscut into 33 squares, 3½" x 3½"

9 strips, 2" x 42"; crosscut into:
• 16 rectangles, 2" x 12½"
• 12 rectangles, 2" x 10"

From yellow 4, cut:

1 strip, 3⅞" x 42"; crosscut onto 4 squares, 3⅞" x 3⅞". Cut each square once diagonally to yield 8 half-square triangles. From the remaining strip, cut 1 square, 3½" x 3½".

1 strip, 3½" x 42"; crosscut into 11 squares, 3½" x 3½"

4 strips, 2" x 42"; crosscut into:
• 8 rectangles, 2" x 12½"
• 4 rectangles, 2" x 10"

From the fat eighths of assorted green prints, cut a _total_ of:

32 rectangles, 2" x 10"

25 squares, 2" x 2"

From the green tone-on-tone fabric, cut:

6 strips, 2" x 42"

Making the Tulip Units

You'll make a total of 32 tulip units in the following fabric combinations: 4 units using pink 1 and yellow 1, 12 units using pink 2 and yellow 2, 12 units using pink 3 and yellow 3, and 4 units using pink 4 and yellow 4. After sewing each seam, press the seam allowances in the direction indicated by the arrows.

1. Sew pink triangles and yellow triangles together along the long edges. Make the number of triangle-square units indicated for each fabric combination.

Pink 1 and yellow 1.
Make 8.

Pink 2 and yellow 2.
Make 24.

Pink 3 and yellow 3.
Make 24.

Pink 4 and yellow 4.
Make 8.

2. Using two matching triangle squares, one matching 3½" yellow square, and one matching 3½" pink square, lay out the squares in a four-patch arrangement as shown. Sew the squares together in rows. Sew the rows together to complete a tulip unit. Make the number of units indicated for each fabric combination.

Make 4.

Make 12.

Make 12.

Make 4.

Making Double-Four-Patch Units

1. Sew 2" x 10" assorted green and yellow rectangles together along their long edges to make strip sets. Press the seam allowances toward the green strips. Make the number of strip sets indicated for each color combination. Crosscut each strip set into the number of 2"-wide segments indicated.

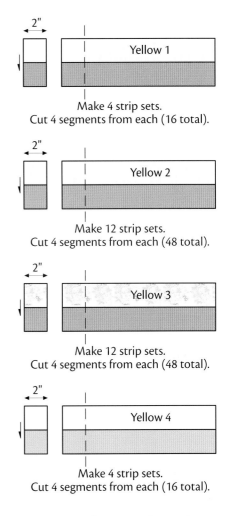

Make 4 strip sets.
Cut 4 segments from each (16 total).

Make 12 strip sets.
Cut 4 segments from each (48 total).

Make 12 strip sets.
Cut 4 segments from each (48 total).

Make 4 strip sets.
Cut 4 segments from each (16 total).

2. Sew two segments from step 1 together as shown to make four-patch units. Make the number of units indicated for each fabric combination.

Make 16. Make 32. Make 16.

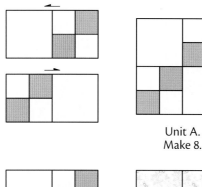

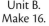

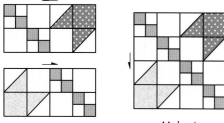

3. Lay out two four-patch units and two 3½" yellow squares as shown for each fabric combination, making sure the four-patch units are positioned so that the small yellow squares and the large yellow squares match. Sew the pieces together in rows, and then sew the rows together to complete the double-four-patch unit, pressing the seam allowances in the direction indicated by the arrows. Repeat with the remaining four-patch units and yellow squares to make the number of units indicated for each color combination.

Unit A.
Make 8.

Unit B.
Make 16.

Unit C.
Make 8.

Making the Blocks

1. Lay out a pink 1 tulip unit, a pink 2 tulip unit, and two double-four-patch A units in a four-patch arrangement as shown, making sure the units are positioned so that the yellow squares match. Sew the units together in rows; press. Sew the rows together; press. Make four of these blocks.

Make 4.

2. In the same manner, make eight blocks using pink 2 tulip units, pink 3 tulip units, and double-four-patch B units. Make four blocks using pink 3 tulip units, pink 4 tulip units, and double-four-patch C units.

Make 8.

Make 4.

Assembling the Quilt

1. Referring to the quilt assembly diagram at right and using a design wall, arrange the blocks, rotating them as shown, so that the pink 1 tulips are in the center. Place the pink 2 tulips around the center, rotating them as shown to form a diamond-shaped pathway. Next place the pink 4 tulips in the corners, again rotating the blocks as shown. Place 2" x 12½" yellow sashing strips between the blocks, matching the fabric in the sashing strip to the yellow fabric in the adjacent blocks. Place 2" assorted green squares between the sashing strips.

2. Sew the blocks and sashing strips together in rows. Sew the assorted green squares and sashing strips together in rows. Press all seam allowances toward the sashing strips.

3. Sew the rows together. Press the seam allowances toward the sashing strips.

4. Refer to "Adding Borders" on page 10 as needed. Sew three 2"-wide green strips together end to end. Make two. Use these strips to make the side, top, and bottom borders. Trim and sew the borders to the quilt top, pressing the seam allowances toward the just-added border strips.

5. Sew three 4½"-wide pink 2 strips together end to end. Use this strip to make the side borders. Sew the remaining pink 2 strips together in pairs. Make two and use these strips to make the top and bottom borders. Trim and sew the borders to the quilt top, pressing the seam allowances toward the just-added border strips.

Finishing the Quilt

1. Layer, baste, and quilt your quilt. In the quilt on page 39, diagonal lines were machine quilted through the center of the green squares. The remainder of the blocks and the border were quilted with meandering feathers, loops, and curls.

2. Refer to "Binding Your Quilt" on page 12 and use the 2½" pink 2 strips to bind your quilt.

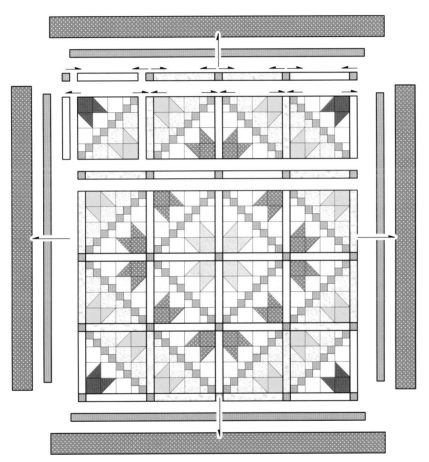

Quilt assembly

Some insects are beneficial to your garden. As honeybees collect nectar, pollen sticks to the fuzzy hairs covering their bodies. Flowers are pollinated when some of the pollen rubs off on subsequent flowers they visit. That means more flowers for you to enjoy!

Materials

Yardage is based on 42" wide fabric.

2⅔ yards of green fabric for blocks, setting triangles, outer border, and binding

1 yard of yellow small-scale floral for blocks

⅞ yard of dark pink tone-on-tone fabric for inner border and appliqués

⅔ yard of light pink tone-on-tone fabric for appliqués

½ yard of yellow-and-pink floral for blocks

½ yard of yellow polka-dot fabric for blocks

½ yard of yellow solid fabric for blocks

¼ yard of green polka-dot fabric for blocks

4 yards of fabric for backing

66" x 66" piece of batting

1⅛ yards of 16"-wide lightweight fusible web (optional)

Cutting

Cut all strips across the width of the fabric.

From the green polka-dot fabric, cut:

4 squares, 6½" x 6½"

From the yellow-and-pink floral, cut:

3 strips, 2½" x 42", crosscut *2 of the strips* into:
* 2 strips, 2½" x 27"
* 1 strip, 2½" x 9"

4 squares, 7¼" x 7¼"; cut twice diagonally to yield 16 quarter-square triangles

From the yellow solid fabric, cut:

8 squares, 6⅞" x 6⅞"; cut once diagonally to yield 16 half-square triangles

From the green fabric, cut:

7 strips, 4½" x 42"

7 binding strips, 2½" x 42"

4 strips, 2½" x 42"; crosscut *2 of the strips* into:
* 1 strip, 2½" x 27"
* 2 strips, 2½" x 9"

2 squares, 18¼" x 18¼"; cut twice diagonally to yield 8 quarter-square triangles

2 squares, 9⅜" x 9⅜"; cut once diagonally to yield 4 half-square triangles

From the yellow polka-dot fabric, cut:

9 squares, 7¼" x 7¼"; cut twice diagonally to yield 36 quarter-square triangles

From the yellow small-scale floral, cut:

18 squares, 6⅞" x 6⅞"; cut once diagonally to yield 36 half-square triangles

From the dark pink tone-on-tone fabric, cut:

6 strips, 1½" x 42"

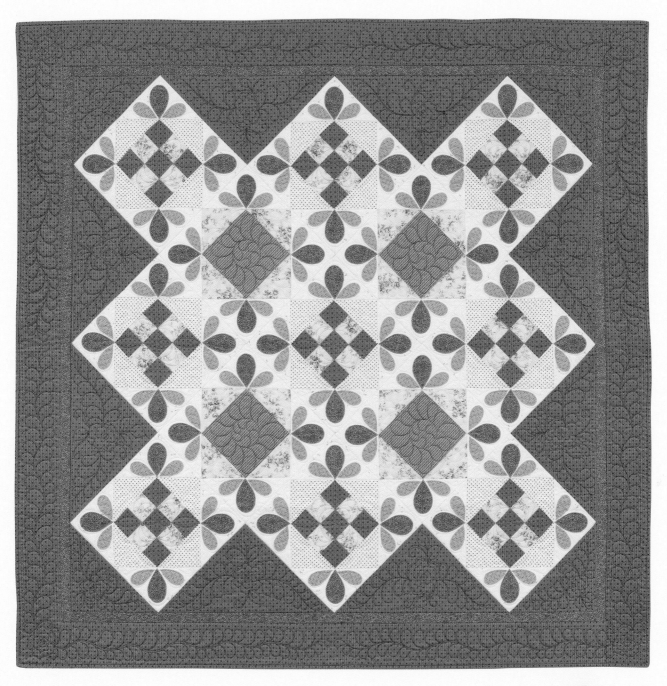

Finished quilt: 61½" x 61½"

Finished block: 12" x 12"

Pieced and appliquéd by Cindy Lammon; quilted by Terri Kanyuck

Making Block A

After sewing each seam, press the seam allowances in the direction indicated by the arrows.

1. Center and sew yellow-and-pink floral quarter-square triangles to opposite sides of a green polka-dot square. Sew triangles to the remaining two sides of the square as shown. Make four.

Make 4.

2. Center and sew yellow solid half-square triangles to opposite sides of each unit from step 1. Sew triangles to the remaining sides of each unit as shown to complete the block. Make four A blocks.

Block A.
Make 4.

Making Block B

After sewing each seam, press the seam allowances in the direction indicated by the arrows.

1. Sew a 2½" x 27" yellow-and-pink floral strip to each long side of the 2½" x 27" green strip as shown to make a strip set. Crosscut the strip set into nine segments, 2½" wide.

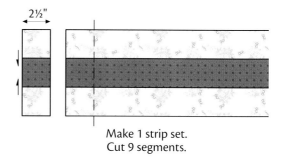

Make 1 strip set.
Cut 9 segments.

2. Sew a 2½" x 42" green strip to each long side of the 2½" x 42" yellow-and-pink floral strip as shown to make a long strip set. In the same manner, sew 2½" x 9" green strips and the yellow-and-pink floral strip together to make a short strip set. Crosscut the strip sets into a total of 18 segments, 2½" wide.

Make 1 long and 1 short strip set.
Cut 18 segments.

3. Sew one segment from step 1 between two segments from step 2 as shown. Make nine.

Make 9.

4. Center and sew yellow polka-dot quarter-square triangles to opposite sides of a unit from step 3. Sew triangles to the remaining two sides of the unit as shown. Make nine.

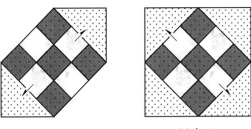

Make 9.

5. Center and sew yellow small-scale floral half-square triangles to opposite sides of the unit from step 4. Sew triangles to the remaining two sides of the unit as shown to complete the block. Make nine B blocks.

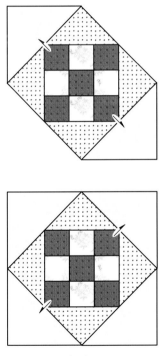

Block B.
Make 9.

Adding the Appliqué

1. Refer to "Hand-Appliqué Techniques" on page 7 or "Fusible Machine Appliqué" on page 10 for guidance as needed. Use the patterns on page 49 and the dark pink tone-on-tone fabric to prepare 52 of A and the light pink tone-on-tone fabric to prepare 104 of B.

2. Using the placement diagram for guidance, place one dark pink A piece and two light pink B pieces in each block corner triangle, taking care to position the pieces so that they will not extend into the outer ¼" seam allowance of the block. When satisfied with the placement, appliqué in place.

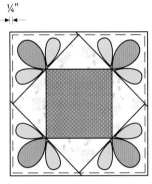

Make 4.

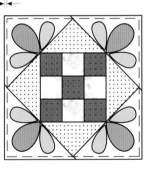

Make 9.

47

Assembling the Quilt

1. Arrange the A and B blocks in diagonal rows as shown in the quilt assembly diagram. Add the green quarter-square triangles along the sides and the green half-square triangles in the corners. Sew the blocks together in diagonal rows. Press the seam allowances toward the setting triangles and the A Blocks. Sew the rows together; press.

2. Referring to "Adding Borders" on page 10, use the 1½"-wide dark pink tone-on-tone strips to make the side, top, and bottom inner borders. Trim and sew the borders to the quilt top, pressing the seam allowances toward the newly added border strips.

3. Use the 4½"-wide green strips to make the side, top, and bottom outer borders. Trim and sew the borders to the quilt top, pressing the seam allowances toward the newly added border strips.

Finishing the Quilt

1. Layer, baste, and quilt your quilt. In the quilt on page 45, the appliqué was echo quilted and feathers were quilted in the triangles and borders. Loops were quilted in the B blocks.

2. Refer to "Binding Your Quilt" on page 12 and use the 2½"-wide green strips to bind your quilt.

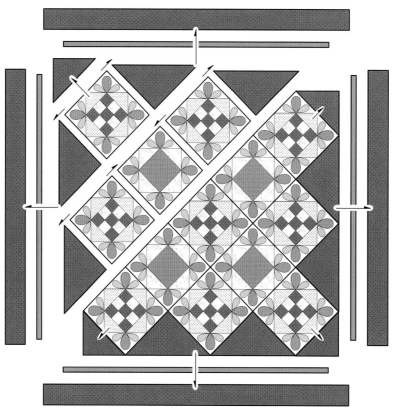

Quilt assembly

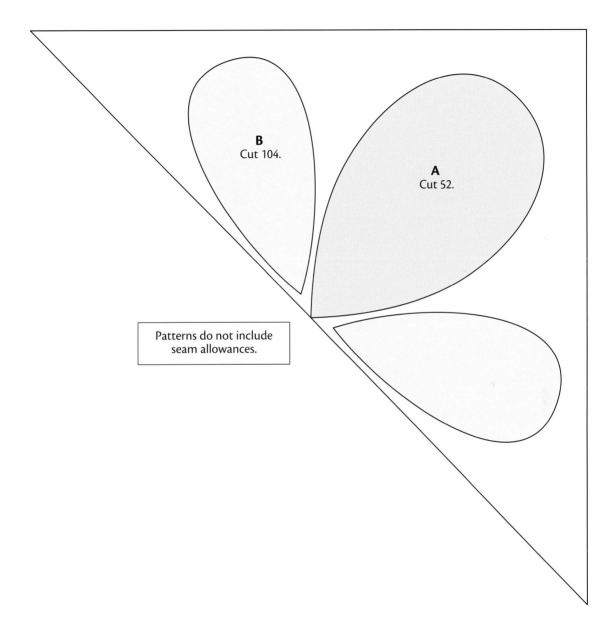

B
Cut 104.

A
Cut 52.

Patterns do not include
seam allowances.

Named after my granddaughter, Elyse, this quilt reminds me of the day I carried her out to the garden for the first time. At nine months old, she was fascinated by the colors and the feel of the plants. That experience allowed me to look at my garden with new eyes. I look forward to the day we can garden together and share the simple, therapeutic pleasure that gardening offers. Be sure to enjoy your garden with the children in your life. You'll experience it in a whole new light.

Materials

Yardage is based on 42" wide fabric.
Fat quarters measure 18" x 21" and fat eighths measure 9" x 21".

2⅞ yards of large-scale red floral for center block, borders, and binding

2⅜ yards of cream polka-dot fabric for border blocks, appliqué background, and borders

⅞ yard of green tone-on-tone print for border blocks and Square-in-a-Square blocks

5 fat quarters of assorted green prints for stem and leaf appliqués and Square-in-a-Square blocks

3 fat quarters of assorted red prints for flower and berry appliqués and Square-in-a-Square blocks

1 fat quarter of red-and-cream print for flower center appliqués and Square-in-a-Square blocks

1 fat quarter of pink print for flower center appliqués and Square-in-a-Square blocks

3 fat eighths of assorted red, green, and/ or pink prints for Square-in-a-Square blocks

4½ yards of fabric for backing

75" x 75" piece of batting

1⅛ yards of 16"-wide lightweight fusible web (optional)

Erasable or water-soluble marker

Cutting

Cut all strips across the width of the fabric unless otherwise noted.

From the *lengthwise* grain of the large-scale red floral, cut:

4 strips, 6½" x 72"

3 squares, 8⅞" x 8⅞"; cut twice diagonally to yield 12 quarter-square triangles

12 squares, 5⅞" x 5⅞"

From the *crosswise* grain of the large-scale red floral, cut:

8 binding strips, 2½" x 42"

From the cream polka-dot fabric, cut:

5 strips, 6½" x 42"

1 strip, 5⅞" x 42"; crosscut into 32 rectangles, 1⅛" x 5⅞"

24 strips, 1½" x 42"; crosscut *8 of the strips,* into 188 squares, 1½" x 1½"

1 strip, 1⅛" x 42"; crosscut into 4 rectangles, 1⅛" x 7"

4 squares, 2½" x 2½"

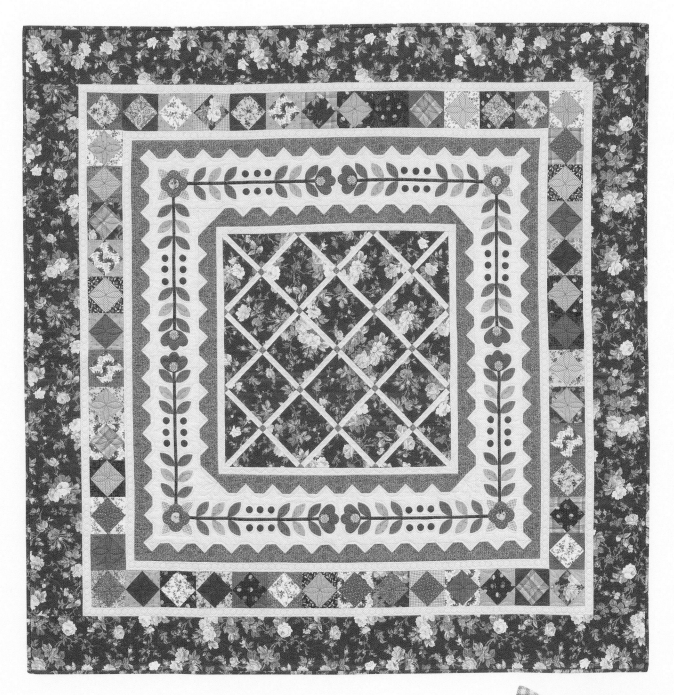

Finished quilt: 70½" x 70½"

Pieced and appliquéd by Cindy Lammon; machine quilted by Terry Kanyuk

From the green tone-on-tone print, cut:

6 strips, 3½" x 42"; crosscut into 92 rectangles, 2½" x 3½"

4 squares, 2½" x 2½"

2 squares, 2⅛" x 2⅛"; cut twice diagonally to yield 8 quarter-square triangles

4 squares, 1½" x 1½"

13 squares, 1⅛" x 1⅛"

From *each* of the 10 fat quarters of green, red, red-and-cream, and pink prints and the 3 fat eighths of red, green and/or pink prints, cut:

4 squares, 3⅜" x 3⅜" (52 total)

8 squares, 2⅞" x 2⅞"; cut once diagonally to yield 16 half-square triangles (208 total)

From the remainder of one green fat quarter, cut:

8 strips, ⅞" x 15½"

Piecing the Center Block

1. Lay out the red floral squares and quarter-square triangles, the 1⅛" x 5⅞" cream rectangles, the 1⅛" green squares, and green quarter-square triangles as shown in the block diagram above right, placing the 1⅛" x 7" cream rectangles at the corners. Sew the pieces together into diagonal rows. Press the seam allowances in the direction indicated by the arrows. The cream rectangles will extend beyond the triangles in each corner. Sew the rows together, pressing the seam allowances toward the red floral pieces.

Trim the corner rectangles to square up the block as shown.

Trim.

2. Referring to "Adding Borders" on page 10 and using four of the 1½"-wide cream strips, trim and sew the strips to the center block from step 1. Press the seam allowances toward each newly added strip. Trim the unit to measure 27½" x 27½", making sure to keep the block centered. You will be trimming approximately ¼" off of each side.

Making the First Pieced Border

1. Using your preferred marker and a ruler, draw a line from corner to corner on the wrong side of the 1½" cream and green squares.

2. With right sides together, place a marked cream square on adjacent corners of a 2½" x 3½" green rectangle as shown, noting the direction of the line. Sew on the marked line. Trim the excess fabric leaving a ¼" seam allowance. Press the seam allowances in the direction indicated by the arrows. Make 92.

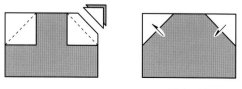

Make 92.

3. In the same manner, sew a marked cream square to one corner of a 2½" green square; trim and press. Make four. (Set these aside for the second pieced border.) Sew a marked green square to one corner of a 2½" cream square. Make four.

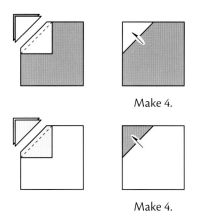

Make 4.

Make 4.

4. Sew nine units from step 2 together into a row; press the seam allowances open. Make four rows. Sew two of these rows to opposite sides of the quilt center. Press the seam allowances toward the center.

5. Sew a cream square with a green triangle from step 3 to each end of each remaining row from step 4; press. Sew these rows to the top and bottom of the quilt center. Press the seam allowances toward the center. Set the remaining units aside for the second pieced border.

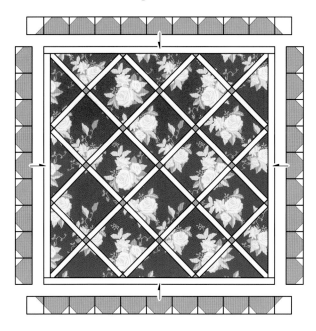

Adding the Appliqué Border

Refer to "Hand-Appliqué Techniques" on page 7 or "Fusible Machine Appliqué" on page 10 and the photo on page 51 for color guidance as needed.

1. Trim two of the 6½"-wide cream strips to 35" long. Sew the remaining three 6½"-wide cream strips together end to end and cut two strips, 44" long.

2. Refer to the diagram on page 54 to mark the strips for appliqué placement using an erasable or water-soluble marker. Fold each cream strip from step 1 in half in both directions and finger-press to make centering creases. Draw a 15½" line on the lengthwise crease starting 2" from the crosswise crease. Repeat on the opposite end of the strip.

3. Referring to "Preparing Stems" on page 8, use the ⅞"-wide green strips to prepare eight stems. Refer to the photo and center a stem over each marked line. Appliqué two stems onto each cream strip. On each of the 35"-long strips, stop stitching 3½" from each end of the cream strip, leaving the end of the stem free for now.

4. Use the pattern pieces on page 56 and four of the assorted green prints to prepare 32 leaves (A) in matching pairs from each of three of the prints; use the fourth green print to prepare 16 leaves (E). Use one red print to prepare eight flowers (C), the second red print to prepare four flowers (F), and the third red print to prepare 48 berries (B). Use the red-and-cream print to prepare eight flower centers (D) and the pink print to prepare four flower centers (D).

5. For leaf placement, measure from the crosswise crease and make a dot on each side of the stem at the following distances: 3½", 5¼", 7", 12½", 14¼", and 16". Measure 1⅝" from the lengthwise crease and make a second dot on each side of the stem at the following distances from the crosswise crease: 2⅛", 3⅞", 5⅝", 11¼", 13", and 14¾". Mark each end of each cream strip. Appliqué the leaves (A) in matching pairs, placing the points of the leaves on the dots. On each

35"-long strip, wait to stitch the last pairs of leaves on each end for now.

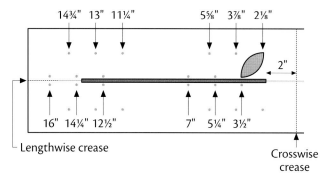

Lengthwise crease

Crosswise crease

6. For placement of the berries, measure ⅞" from the lengthwise crease and make a dot on each side of the stem at the following distances from the crosswise crease: 7⅝", 8⅞", and 10⅛". Center the berries (B) on the dots and appliqué in place.

7. Position flower (C) ¼" from the crosswise crease. Appliqué the flower and red-and-cream flower center (D) to the cream strip.

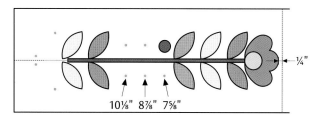

8. Trim each 35"-long appliquéd cream strip to 6" x 31½", making sure to keep the design centered. Trim the 44"-long strips to 6" x 42½", centering the design.

9. Sew the 31½"-long strips to the sides of the quilt center. Sew the 42½"-long strips to top and bottom.

10. On both ends of the shorter strips, appliqué the remaining 3½" of each stem, and then stitch the remaining pairs of leaves.

11. On each corner, measure 3" from each raw edge and make a dot for placement of the corner flower. Position and appliqué the corner leaves (E), flowers (F), and pink flower centers (D),

centering the design on the marked dot. The quilt center should measure 42½" square.

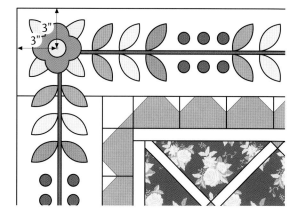

Adding the Second Pieced Border

1. Referring to the quilt assembly diagram at right and using the units left over from step 2 of "Making the First Pieced Border" on page 52; sew 14 units together to make a row. Make four rows. Sew two of these rows to the top and bottom of the quilt. Press the seam allowances toward the appliqué border strips.

2. Using the units from step 3 of "Making the First Pieced Border" and referring to the assembly diagram for orientation, sew a green square with a cream triangle to each end of each remaining row. Sew these rows to the sides of the quilt top. Press the seam allowances toward the appliqué border strips.

Making the Square-in-a-Square Blocks

From the red, green, pink, and red-and-cream pieces, choose four matching half-square triangles and one 3⅜" square. Center and sew triangles to opposite sides of the square; press. Center and sew triangles to the remaining sides; press. Make a total of 52 blocks.

Make 52.

Adding the Final Borders

Refer to the quilt assembly diagram below for guidance as needed.

1. Sew three 1½"-wide cream strips together end to end. Make four. From these strips, cut two 46½"-long, two 48½"-long, two 56½"-long, and two 58½"-long border strips.

2. Sew the 46½"-long strips to the sides of the quilt top; press the seam allowances toward the cream strips. Sew the 48½"-long strips to the top and bottom of the quilt top; press. The quilt center should measure 48½" square.

3. Sew the Square-in-a-Square blocks together into two rows of 12 blocks each and two rows of 14 blocks each. Sew the 12-block rows to the sides of the quilt top; press the seam allowances toward the cream strips. Sew the 14-block rows to the top and bottom of the quilt top; press.

4. In the same manner as before, sew the 56½"-long cream strips, and then the 58½"-long cream strips to the quilt top.

5. Referring to "Adding Borders" on page 10, use the 6½"-wide red floral strips to make the side, top, and bottom borders. Trim and sew the borders to the quilt top, pressing the seam allowances toward the border strips.

Finishing the Quilt

1. Layer, baste, and quilt your quilt. The quilt on page 51 was machine quilted with large flowers in the center squares. The appliqué motifs were echo quilted with scallops along the green pieced border. Loops were quilted to connect the Square-in-a-Square blocks and a feather design was quilted in the outer borders.

2. Refer to "Binding Your Quilt" on page 12 and use the 2½"-wide red floral strips to bind your quilt.

Quilt assembly

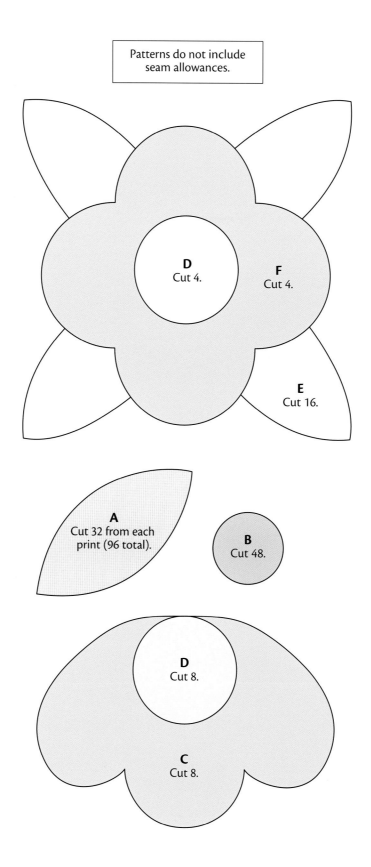

Patterns do not include
seam allowances.

D
Cut 4.

F
Cut 4.

E
Cut 16.

A
Cut 32 from each
print (96 total).

B
Cut 48.

D
Cut 8.

C
Cut 8.

Christmas plants are a beautiful part of holiday decorating, often forgotten in the busyness of shopping, baking, and decking the house. I always include some poinsettias and holly in my decor. It reminds me of the days when holiday decorating came from the garden—nature's final gift before hibernating for the winter.

Materials

Yardage is based on 42" wide fabric.

1 yard of cream tone-on-tone fabric for appliqué background

¾ yard of cream polka-dot fabric for background

¾ yard of red-and-green floral for outer border

⅝ yard of red-and-green plaid for appliqués and binding

⅝ yard *total* of assorted green scraps for appliqués

½ yard of red tone-on-tone fabric 1 for blocks

⅜ yard of red tone-on-tone fabric 2 for appliqués and inner border

¼ yard of green tone-on-tone fabric for blocks

¼ yard *total* of assorted red scraps for appliqués

3 yards of fabric for backing

49" x 49" piece of batting

1 yard of 16"-wide lightweight fusible web (optional)

Cutting

Cut all strips across the width of the fabric unless otherwise noted.

From the cream tone-on-tone fabric, cut:

2 strips, 7" x 42"; crosscut into 8 squares, 7" x 7"

1 strip, 3¼" x 42"; crosscut into 8 squares, 3¼" x 3¼". Cut each square twice diagonally to yield 32 quarter-square triangles.

1 square, 12½" x 12½"

From the red tone-on-tone fabric 1, cut:

3 strips, 2⅞" x 42"; crosscut into 32 squares, 2⅞" x 2⅞". Cut each square once diagonally to yield 64 half-square triangles.

2 strips, 1½" x 42"; crosscut into:
• 2 rectangles, 1½" x 14½"
• 2 rectangles, 1½" x 12½"

From the cream polka-dot fabric, cut:

1 strip, 3¼" x 42"; crosscut into 12 squares, 3¼" x 3¼". Cut each square twice diagonally to yield 48 quarter-square triangles.

3 strips, 2⅞" x 42"; crosscut into 32 squares, 2⅞" x 2⅞". Cut each square once diagonally to yield 64 half-square triangles.

2 strips, 2½" x 42"; crosscut into 32 squares, 2½" x 2½"

1 strip, 4½" x 42"; crosscut into 16 rectangles, 2½" x 4½"

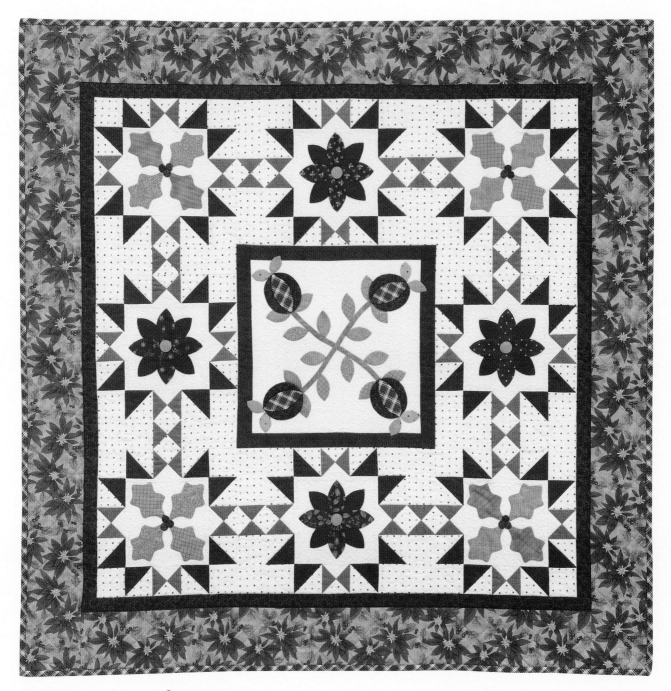

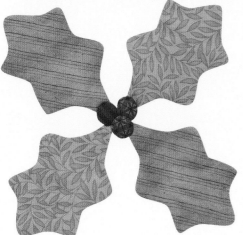

Finished quilt: 44½" x 44½"

Finished block: 10" x 10"

Pieced, appliquéd, and machine quilted by Cindy Lammon

From the green tone-on-tone fabric, cut:

2 strips, 3¼" x 42"; crosscut into 20 squares,
3¼" x 3¼". Cut each square twice diagonally
to yield 80 quarter-square triangles.

From the *bias* of the assorted green scraps, cut:

2 strips, ⅞" x 9½"

From the red tone-on-tone fabric 2, cut:

4 strips, 1½" x 42"

From the red-and-green floral, cut:

5 strips, 4½" x 42"

From the *bias* of the red-and-green plaid, cut:

Enough 2½"-wide strips to total 188"*

For straight-grain binding, cut 5 strips, 2½" x 42".

Making the Pomegranate Block

1. Sew 1½" x 12½" red 1 rectangles to opposite
 sides of the 12½" cream square and press the
 seam allowances toward the red rectangles. Sew
 the 1½" x 14½" red 1 rectangles to the remaining
 sides of the square; press.

2. Refer to "Hand-Appliqué Techniques" on page
 7 or "Fusible Machine Appliqué" on page 10 for
 guidance as needed. Fold the background block
 from step 1 in half in both directions and finger-
 crease to establish centering lines. The Pome-
 granate pattern on page 63 represents one-fourth
 of the appliqué design. Align the creases in the
 background block with the long dashed lines on
 the quarter pattern, rotating the pattern around
 the center point to complete the design. Refer-
 ring to "Preparing Stems" on page 8, use the
 ⅞"-wide green bias strips to prepare stems.

3. Use the pattern pieces on page 63 and the
 assorted red scraps to prepare four outer petals
 (B) and the red-and-green plaid to prepare four
 inner petals (C). Use the assorted green scraps to
 prepare four of leaf A, eight of leaf D, and eight
 of leaf E.

4. Referring to the placement diagram below, appli-
 qué the stems, and then the remaining pieces in
 alphabetical order, noting that one leaf in each
 corner overlaps the red border of the block.

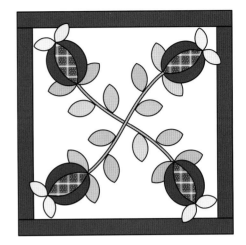

Appliquéing the Holly and Poinsettia Blocks

1. Fold each 7" cream square in half in both direc-
 tions, and then diagonally in both directions;
 finger-crease to establish crease lines for posi-
 tioning.

2. Use the pattern pieces on page 62 and the
 assorted green scraps to prepare 16 holly leaves
 (F) and four flower centers (J). Use the remain-
 ing assorted red prints to prepare 12 holly cen-
 ters (G), 16 flower petals (I) in matching sets of
 four petals, and 16 flower petals (H) in matching
 sets of four petals.

3. Refer to the placement diagrams on page 60 and
 use the crease lines you made to position the
 holly appliqués or the poinsettia appliqués on the
 cream squares. Appliqué the pieces in alpha-
 betical order to each cream square. Make four
 Poinsettia blocks and four Holly blocks. Trim

the blocks to 6½" x 6½", making sure to keep the appliqué design centered in the block.

6½"

6½"

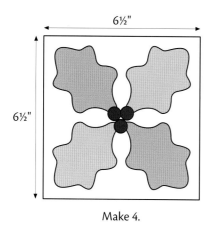

Make 4.

6½"

6½"

Make 4.

Piecing the Blocks

After sewing each seam, press the seam allowances in the direction indicated by the arrows.

1. Sew red 1 half-square triangles and cream polka-dot half-square triangles together along their long edges to make a triangle square. Make 64 triangle squares.

Make 64.

2. Sew a green quarter-square triangle to a cream polka-dot quarter-square triangle with their short edges aligned and the green triangle on top. Make 32 units. In the same manner, sew green quarter-square triangles and cream quarter-square triangles together. Make 32 of these units. Sew the units together in pairs as shown to make 32 hourglass units.

Make 32.

3. Sew a triangle-square unit from step 1 to each side of an hourglass unit from step 2 as shown. Make 32.

Make 32.

4. Lay out four 2½" cream polka-dot squares, four units from step 3, and one appliquéd block as shown. Sew the pieces together in rows. Sew the rows together to complete the block. Make four Holly blocks and four Poinsettia blocks.

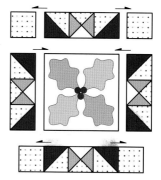

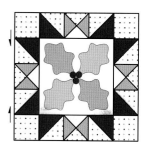

Make 4.

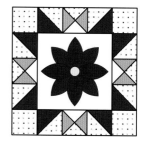

Make 4.

Making the Sashing Units

1. Sew a green quarter-square triangle to a cream polka-dot quarter-square triangle with their short edges aligned and the green triangle on top; press. Make 16 units. Sew the units together in pairs to make eight hourglass units.

Make 8.

2. Sew 2½" x 4½" cream polka-dot rectangles to opposite sides of each unit from step 1 as shown to make a sashing unit; press. Make eight.

Make 8.

Assembling the Quilt

1. Sew a sashing unit to each side of a Poinsettia blocks as shown; press. Make four.

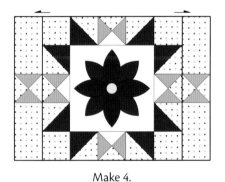

Make 4.

2. Sew a Poinsettia block from step 1 to each side of the Pomegranate block as shown; press. Make one row.

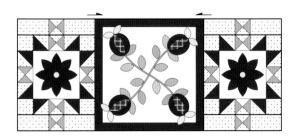

3. Sew a Holly block to each side of a remaining Poinsettia block as shown; press. Make two rows.

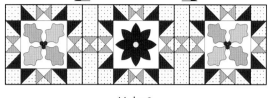

Make 2.

4. Lay out the three block rows as shown, with a Holly Block in each corner. Sew the rows together and press the seam allowances toward the center row.

5. Referring to "Adding Borders" on page 10, use the 1½"-wide red 2 strips to make the side, top, and bottom inner borders. Trim and sew the borders to the quilt top, pressing the seam allowances toward the newly added border strips.

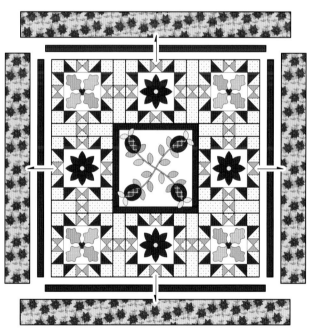

Quilt assembly

6. Use the 4½"-wide red-and-green floral strips to make the side, top and bottom outer borders. Trim and sew the borders to the quilt top, pressing the seam allowances toward the newly added border strips.

Finishing the Quilt

1. Layer, baste, and quilt your quilt. In the quilt on page 58, the appliqué background was machine stippled after stitching in the ditch around the pieced blocks. Loops were quilted around the blocks, and a grid was quilted in the border.

2. Refer to "Binding Your Quilt" on page 12 and use the 2½"-wide red-and-green plaid strips to bind your quilt.

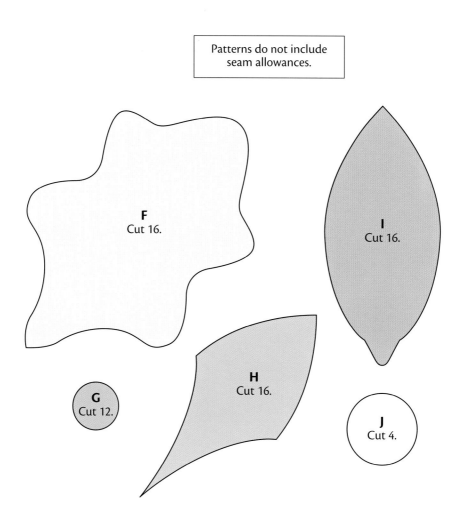

Patterns do not include seam allowances.

F
Cut 16.

I
Cut 16.

H
Cut 16.

G
Cut 12.

J
Cut 4.

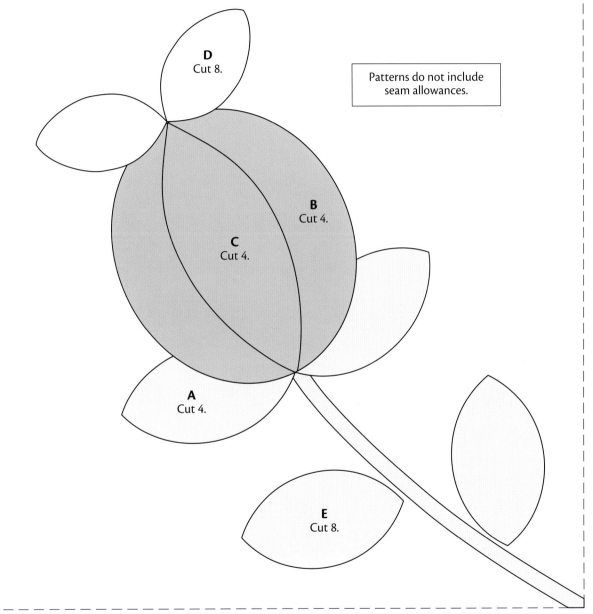

D
Cut 8.

Patterns do not include
seam allowances.

B
Cut 4.

C
Cut 4.

A
Cut 4.

E
Cut 8.

Rotate and align pattern on dashed lines.

About the Author

Cindy Lammon attempted to make her first quilt while still a high-school student. The Double Wedding Ring quilt never went together well, so in 1981 she took her first real quilting class. A love of fabric, pattern, and design has fueled her passion for quilting for over 28 years. She enjoys machine piecing and machine quilting, but she also loves hand quilting and hand appliqué.

Cindy teaches beginning quiltmaking and machine quilting at Raspberry Patch Quilt Shop in Cottleville, Missouri, in addition to teaching and lecturing for quilt guilds. This is her third book with Martingale & Company.

In addition to quilting, Cindy loves to read, cook, decorate, and garden. Her future pursuit is to share these passions with her grandchildren!

SEE MORE ONLINE!

Find quilt patterns, class descriptions, teaching schedules, and Cindy's blog at www.hyacinthquiltdesigns.com.

Learn more about Cindy and her books at www.martingale-pub.com.